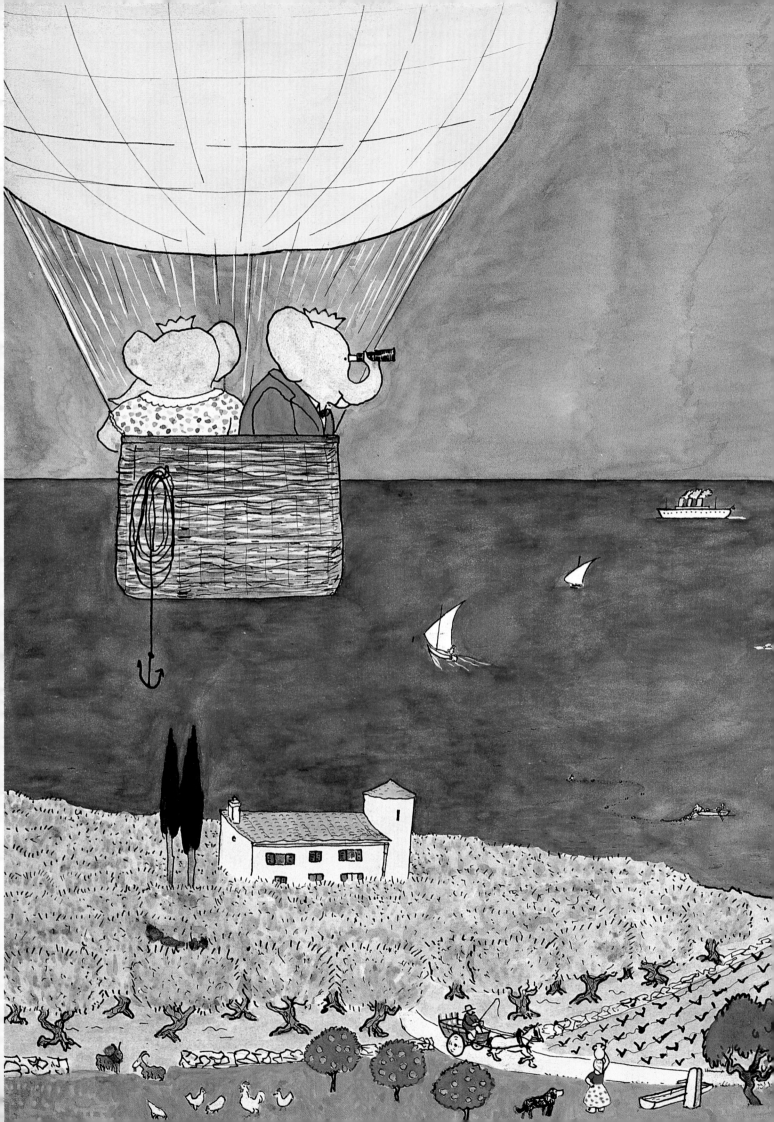

THE ART OF BABAR

THE ART OF BABAR

The Work of
Jean and Laurent de Brunhoff

By Nicholas Fox Weber

Harry N. Abrams, Inc., Publishers, New York

For Lucy and Charlotte

All line drawings through page 9 were created by
Jean de Brunhoff for the children's dining room,
S S Normandie (c. 1934)

The title page illustration by Jean de Brunhoff
is *The Balloon Ride* from *The Travels of Babar* (1932)

Editor: Darlene Geis
Designer: Maria Miller
Photography: Phil Pocock
Family photographs courtesy Mme. Cécile de Brunhoff
and Mme Marie-Claude de Brunhoff

Library of Congress Cataloging-in-Publication Data
Weber, Nicholas Fox, 1947–
The art of Babar: the work of Jean and Laurent de Brunhoff/by
Nicholas Fox Weber.
p. cm.
Bibliography: p.
Includes index.
ISBN 0–8109–1893–5
1. Brunhoff, Jean de, 1899–1937—Characters—Babar. 2. Brunhoff,
Laurent de, 1925– —Characters—Babar. 3. Babar (Fictitious
character) 4. Children's stories, French—History and criticism.
5. Illustrated books, Children's—France. 6. Elephants in
literature. 7. Elephants in art. I. Title.
PQ2603.R9453Z95 1989
843′.912—dc19 89–115

Contents

Preface

It was a picture book childhood, in memory like endless Bonnards of sunny days and domestic comforts. On clear summer mornings the two young brothers would ride their bicycles past honeysuckles in full bloom. They often visited their tree house and played *cache-cache* (hide-and-seek) with their cousins, whom they adored. Afterwards they could cool off in the Marne, the gently flowing river that was a fifteen-minute walk from their grandfather's large Directoire-style country house in Chessy, a small Île-de-France village some twenty kilometers from Paris.

Their mother was calm and elegant, her face with its delicate features most often graced with a serene smile; their father tall and handsome and, for a Frenchman in the 1920s, extraordinarily attentive and indulgent. The broader cast of characters included dapper and lively uncles who would arrive from time to time in their roadsters, talented and devoted grandparents with a big house in Paris, a butler who knew when to joke and when to serve, and the perfect plump and kindly cook.

When the boys were aged three and four their father began to teach them how to ski in Vermala, a quiet resort in the French part of Switzerland. From then on they went there for several months every winter, between stops at their small flat in Paris where Papa, a painter, had his tiny studio. The boys continued their education by correspondence when they were traveling, with their nurse supervising their lessons so no one had to worry about bothersome school schedules.

One summer evening in 1930, Mama invented a story of an intrepid and well-mannered elephant for five-year-old Laurent and four-year-old Mathieu. Mathieu had a stomachache that night, and although Cécile de Brunhoff had never made up a story before, she created the tale in hope of soothing him. She

told it to her sons as they lay in their *lits-cages,* beds with slatted railings and scrollwork, designed to fold back to make more play space during the day. They were in a high-ceilinged bedroom with big windows in the house in Chessy.

The next day they repeated the story to their father. Papa—Jean de Brunhoff—decided to write it down and illustrate it, naming the elephant and embellishing the plot along the way. In his studio in a remote part of the vegetable garden, he made the tale into a book, a single copy intended just for his sons. But in little time Laurent's and Mathieu's uncles, who were publishers, persuaded Jean de Brunhoff to allow them to produce the book, and it was a success. Each year thereafter another volume appeared about the elephant. Occasionally the boys had some say about the contents—for example, they told their father to add their beloved monkey character, Zephir, to a scene where they missed him. The two brothers—and, in little time, thousands upon thousands of other children and adults in France—watched Babar the elephant travel and struggle and triumph. The books were soon translated, and shortly readers in England and America began to follow Babar and his family. But to Laurent and Mathieu de Brunhoff the elephant and his cohorts must have seemed their very own.

And then, as with the shootings and the battles, the snakebites and fires that from time to time shattered the bliss within the pages of the Babar books, something in the de Brunhoffs' own life made their world suddenly come apart. In the spring of 1937, the family did not leave the Alps and head back to Paris and Chessy as usual. The mountain air, it was thought, was the only possible cure for Jean de Brunhoff's bone tuberculosis. In September, when Laurent and Mathieu returned to Paris for school,

their mother, two-year-old brother, Thierry, and father remained behind. A month later Jean de Brunhoff died. The dream of a childhood was over.

In the seven early Babar books, crises and tragedies are usually followed by upturns in the plot within a page or two. There is even a two-page spread in *Babar the King* in which the misfortune, cowardice, anger, sickness, indolence, and fear represented by vicious demons on the left-hand page are driven away the moment one glances at the goodness, hope, courage, patience, wisdom, and joy embodied by angelic elephants on the right. For the de Brunhoffs, solutions were not, in reality, quite so quick. The thirty-three-year-old widow did her best to raise three young boys, but life would never again be the same. A year after her husband died at the age of thirty-seven, her father—the beloved grandfather with the house in Chessy—died as well. Then came the war and the occupation of Paris: years of struggle and privation.

But in 1946 Babar was resurrected. With him, aspects of that enchanted childhood and wonderful father emerged again. Laurent de Brunhoff, an abstract painter working in Montparnasse, had often enough drawn the elephant and the other inhabitants of his kingdom for his own amusement; now he took his turn at doing a Babar book. He published *Babar's Cousin: That Rascal Arthur.* Since then he has taken Babar to distant planets, to California, and underground, employed him as a teacher, had his family grow. Laurent has, to date, made over thirty Babar books, and the optimistic hero who was born at the start of the 1930s in a mother's imagination in the nursery of an Île-de-France manor house is still alive and thriving. "The king is dead; long live the king."

Beginnings
The Work of Jean de Brunhoff

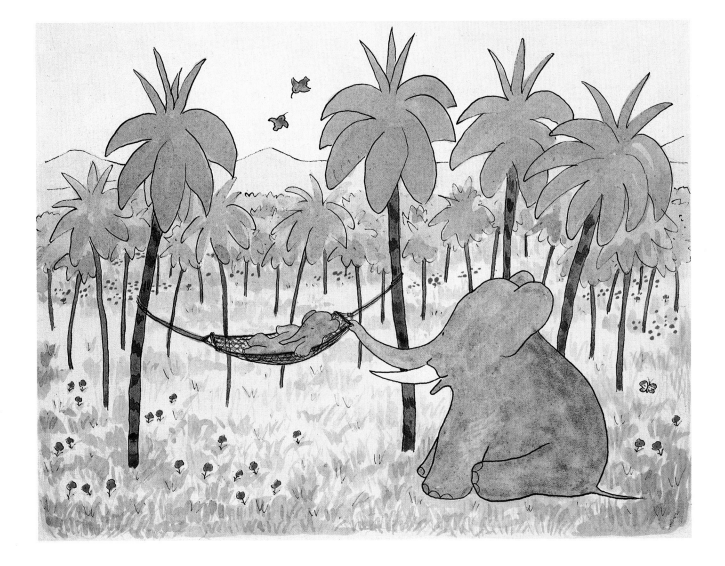

Jean de Brunhoff, August, 1924

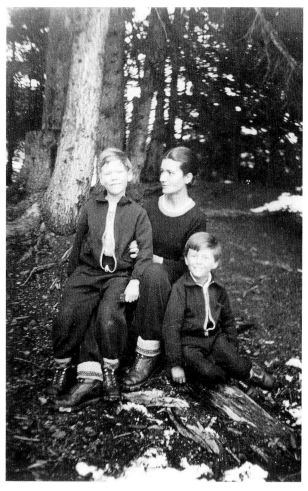

Cécile and the boys, Vermala, 1933

Preceding page:
THE STORY OF BABAR (1931)
"In the great forest a little elephant is born."
Ink and watercolor, 19×26 cm (7½×10″)

B orn on December 9, 1899, Jean de Brunhoff spent his childhood surrounded both by the trappings of the century to which he bore three weeks' witness, and by intimations of the modern era. Jean's father, Maurice de Brunhoff, a Frenchman of Swedish, Baltic, and Austrian ancestry, was a well-known Parisian publisher. Maurice's early success in publishing a bible illustrated by James Tissot was followed by his editorship, for over twenty years, of a monthly review called *Comoedia illustré,* which gave a unique view of the contemporary theatrical scene. He edited books on the art of Léon Bakst and produced programs for Sergei Diaghilev's Ballets Russes. Those programs were of such quality that they significantly elevated the notion of the importance of theater programs in general. Maurice's wife was a sturdy and competent woman from Alsace. Of traditional values, she devoted herself totally to the well-being of her family.

The flat in which this prosperous couple, their four children—Jean had been preceded by a sister and two brothers—and a suitable retinue of servants lived was on the Place Denfert-Rochereau in Montparnasse. This great open space is the meeting point of numerous boulevards and narrow streets, all defined by handsome six-story buildings with mansard roofs and ornate facades. There is a wonderful light on the square. It feels like being at the midpoint of worldly civilization, and you imbibe the bounty of Paris there.

Right in the middle of the Place Denfert-Rochereau, cordoned off from all traffic (carriages in Jean de Brunhoff's youth, cars today), there is a great bronze lion about eighteen feet long and ten feet high, sculpted in 1880 by Frédéric Auguste Bartholdi, the Alsatian artist who made the Statue of Liberty and other monumental sculptures all over France. Bartholdi's lion must have appealed greatly to young Jean. It symbolized the glory of France that would in more subtle form pervade his books. It was a jungle creature much like the ones he would later create: only as wild as its creator wanted it to be. While modeled on real jungle beasts, the bronze lion and the painted elephants remain distinctly man-made. Totally at the mercy of sculptor or watercolorist, they are as harmless as they are charming, their bestiality on display within the safe confines of urban life.

The lion expresses fury with shock. More puzzled than ferocious, this powerhouse remains childlike and innocent. Bartholdi has carefully crafted its fine, sturdy body to give the sympathetic creature a wonderfully supple strength, precisely the stuff of which childrens' fantasies are made. If Jean de Brunhoff could look from his bedroom window at this marvelous and imposing beast who never twitched a muscle while standing resplendent in a Parisian square, it is no surprise that in due time he would put spats and bowler on an elephant.

Jean de Brunhoff attended a first-rate Protestant grammar school, and then went to L'École Alsacienne behind the Luxembourg Gardens. When he was in his early twenties, he studied art at the Académie de la Grande Chaumière in Paris, where his teacher was Othon Friesz. He was a competent if not particularly original student. The quiet tonality of his work revealed above all his gentle sensibility and lyrical responsiveness. There is a look of contentment and equilibrium to it, not surprising given how quickly life fell neatly into place for the young art student.

In Friesz's studio Jean made friends with a painter, Émile Sabouraud, known as Mio to close acquaintances. Mio, an intensely committed painter now in his late eighties and still living in Paris,

remembers this period well.[1] Mio himself was a fiery student drawn to the art of the Fauves and above all Soutine. Jean de Brunhoff on the other hand was a thin, refined, discreet young man attracted more to the work of Raoul Dufy. A painting from one of his earliest visits to Mio's parents' country house—the house in Chessy where Babar would be invented eight years later—shows an attitude similar to Dufy's, if a more simplified manner. Its hallmark is the uncomplicated enjoyment of the sight of a nice big house, with its belvedere and garden, on a bright summer day.

Mio felt that Jean's work at the time was slowly and carefully done, good in its way but not strong enough for him "to go on with painting through his life." Yet in spite of their differing tastes, he and Jean quickly and naturally developed strong ties. They were both crazy about painting. They trusted each other, they despised fads, they savored everyday living. Additionally, the young artists' backgrounds were similar. Although the Sabourauds were Catholic and the de Brunhoffs Protestant, both families belonged to a segment of the Parisian bourgeoisie that looked to the left not so much in a political as in

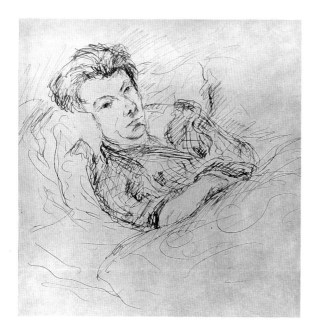

a general way. They both adored music. They both cared deeply about Russian novels and the great books of French literature. Above all, as Mio has said, "Our families were both intensely involved with the discovery of Proust; he was the great, great man for every one of us." Jean de Brunhoff often stayed for dinner at the Sabourauds' house, and after dinner the conversation turned more often to *À la recherche du temps perdu* than to any other subject.

Émile Sabouraud's father was a prominent dermatologist, serious and conscientious, very dignified "even in the country."[2] In the early 1920s, when his children were teenagers, he achieved considerable esteem and financial success for his research on skin fungi and their treatment. The concomitant growth of his practice enabled Dr. Sabouraud to take a big house on the corner of the Rue de Miromesnil and the Avenue de Messine in the eighth arrondissement, near the Rue du Faubourg St. Honoré and the art galleries centered on the Rue La Boétie. When Mio discovered modern paintings in the windows of some of those galleries, he advised his father to begin collecting. He still remembers the reply: "If you are as sure about your tastes as you seem to be, tell me what you like, and I might buy some." By the time Mio brought Jean de Brunhoff home to visit, Dr. Sabouraud had acquired three Soutines, a Renoir, a Redon, and a Utrillo.

Mio says that Jean de Brunhoff was the most beautiful young man one could ever see. "You cannot speak of Jean without mentioning his reserve and his aristocratic outlook and behavior. Jean was as tactful as a man could be. He could speak to anyone—from the gardener to the pope—and be completely simple and natural and close to them." What better person to take home? And time and again Jean returned eagerly to the Sabouraud household, largely because of Mio's pretty and talented sister, a young pianist named Cécile.

Émile Sabouraud (c. 1924)
Pen and ink, 42.7 × 34.5 cm (16¾ × 13½")

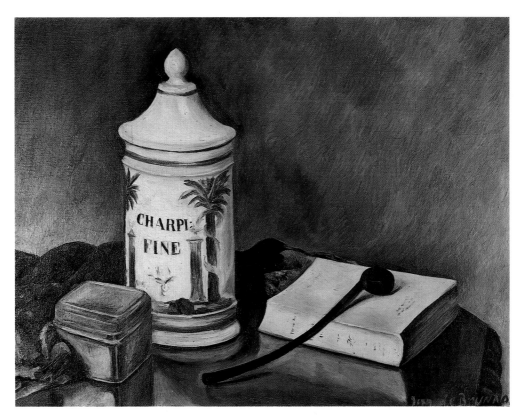

Still Life with Pipe and Book (1922)
Oil on canvas, 45 × 60 cm (17¾ × 23¾″)

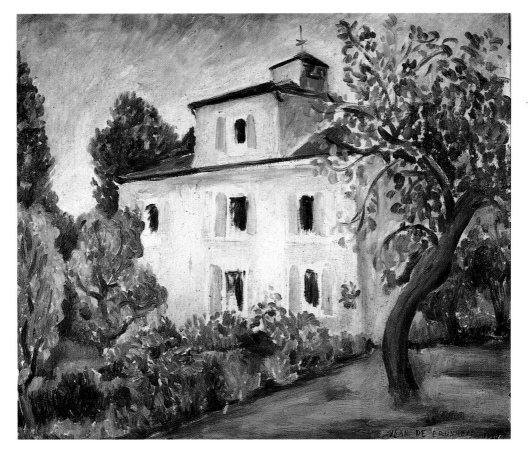

The Sabouraud House in Chessy (1922)
Oil on canvas, 46 × 55 cm (18 × 21¾″)
Collection Cécile de Brunhoff

House in Chessy (1929)
Pen and ink, 28 × 38 cm (11 × 15″)

The Family in Chessy (c. 1929)
Oil on canvas, 38 × 54.5 cm (15 × 21½″)

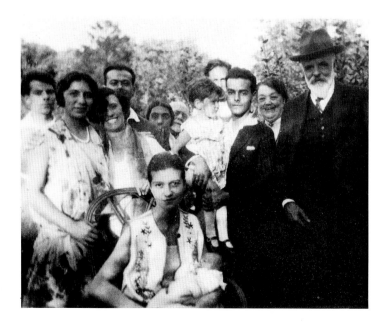

The family in Chessy, summer, 1926.
Cécile de Brunhoff, foreground, holding Mathieu;
Maurice de Brunhoff and his wife on the right

16

In May of 1924, two years after they met, Jean de Brunhoff and Cécile Sabouraud became engaged. They were married that October 28. The early years of their marriage appear to have been a picture album of cultivated French living. The pair were good-looking, affable, and unusually dignified. They were not affluent, but they had sufficient means to get by. Their life was a blend of modern and traditional values; they read Gide, but always had someone to look after the children. Uncle Lucien was a leftist, but at no cost to his prosperity as a publisher. Everything had its place, and life took a smooth course. That ease underlies Jean's paintings of those years—the portrait of his wife pregnant for the first time, a lyrical sketch of the house in Chessy done after he and Cécile had moved into the top floor, and an oil sketch of a family meal in front of the house, painted after the first two boys were born, with Dr. Sabouraud at center stage and the rest of the family in the relaxed poses of a happy summer afternoon get-together.

Jean was unable to make a living as a painter, but both the Sabourauds and the de Brunhoffs supported him and Cécile with a modest allowance. The older generation was happy to subsidize the young creators. Both families prized curiosity and the skills of culture. For Cécile to play piano seemed entirely fitting, since her mother, as well as Jean's oldest brother, also played. Jean and Mio were not the only artists; Dr. Sabouraud, in addition to being a collector of paintings, managed in spite of his busy professional life to be an accomplished sculptor.

To visualize and understand the world of both families, you need only to look at the first Babar books. The hats now sported by elephants, the teapots they hold with their trunks, and the chairs on which they rest their large bottoms are the same as those used half a century ago by the trim, fine-boned lot in Chessy. The piano the Old Lady uses is the one that Cécile and her mother used. Babar's brown backpack is the one that Jean wore when hiking, his cap the one Jean sported when skiing in the mountains. Their daily pleasures fill the pages of Jean de Brunhoff's books; so does their camaraderie. If many cousins and in-laws can hardly wait to be at one another's throats or to pour out venom about one another, not so the de Brunhoffs and the Sabourauds, who were more like Babar and his fellow elephants in their mutual support. That house in Chessy where Jean and Cécile spent half the year was the same place in which her parents and Mio and his family lived in the summertime. Jean adored Cécile's family, and they him. Cécile counted Jean's siblings among her closest friends. The young cousins who made up the next generation frolicked together as happily as the most easygoing citizens of Babar's Celesteville.

Laurent de Brunhoff was born on August 30 in 1925, Mathieu on July 28 of the following year. Jean's largest remaining painting of the period is an able rendering of Laurent at age two on a rocking horse. It suggests the contentment that pervaded the family's early years. As the boys began to grow up, they were happiest during their holidays at the Chessy estate, which became the center of their life. There was plenty of room for them and their parents in Dr. Sabouraud's large house, as well as for Mio and his family, while Cécile's brother Jacques and his family occupied a second house on the property. Between one another and their four cousins, Laurent and Mathieu had constant playmates. It was, in Mathieu's memory, "le vrai paradis."[3] The de Brunhoff and Sabouraud children distinguished themselves from other French youngsters by breakfasting on some rare American delicacies—Rice Krispies

and Kellogg's Corn Flakes in Mathieu's memory, Quaker Oats in Laurent's—with lots of sugar. Their family was a bit more tuned in to the larger world than most of their friends were.

In its big rooms and terrace, the house had lots of play spaces. There was fertile territory for the boys' imaginations: the dark and interesting old furniture in Cécile's parents' rooms, the false marble and the large *poêle,* or tiled stove, in the dining room. The dining room chairs had irregularly grained backs that, in Laurent's and Mathieu's fanciful minds, housed all sorts of four-legged animals and tortoises and a little girl who played with them. The boys also plotted stories based on the contents of the department store catalogues that were in a large drawer in the kitchen and were used for lighting fires in the big stove. A door in that kitchen led to further thrills in a basement that was like a deep grotto. The cellar was so dark that Laurent and Mathieu could only enter it accompanied by an adult. Their guide was either the butler, Jean-Baptiste, invariably clad in his big apron, or their nurse, Rose-Marie, a short, round, blond Swiss girl with her hair in buns on top of her ears. There were places to be amused, and others in which to be serious: the salon had both a large billiard table and a piano. Mathieu says that the piano—played by Cécile's mother (who died when the boys were quite young) and by Cécile—marked the holy place of the house. Outside there were the large vegetable and flower gardens, occupied by a diligent staff and an ever-changing population of dogs and cats.

Each stop in the de Brunhoffs' yearly routine had its charms. In the Alps, where their preferred villages were Montroc, Montana, or Vermala, they stayed in nice chalets. It was a joy for Laurent and Mathieu to taunt Rose-Marie because of her inept skiing. There were two flats in Paris. The first, in Auteuil in the sixteenth arrondissement, consisted of a large studio with Jean and Cécile's bed in a corner of it, a tiny room where the two boys slept in ornate iron beds painted white, a small dining room, and minuscule bathroom. In November of 1934, when Cécile gave birth to a third son and Laurent and Mathieu began to attend the Lycée Pasteur, they took a small apartment in Neuilly, where one room served as a studio and Jean and Cécile slept in the living room so that Laurent and Mathieu could have one bedroom and the baby and nurse another. Being at either location meant not just the diversions of Paris, but also better schools for the boys and proximity to most of the extended de Brunhoff and Sabouraud families.

When the family was staying in Paris or when they visited there from Chessy, Jean de Brunhoff was a regular visitor to the Louvre, where he often copied the great masters. His subjects included antiquities, as well as works by Velázquez, Veronese, and Rubens. His oil copy of Rubens's *Helena Fourment and Her Children* is not extant, but it hung near the dining room table in the Paris flat and was such a part of everyday life that its three subjects seemed like family members. A pencil version remains that shows how Jean de Brunhoff was nourished by the delicacy and fluidity of the Flemish master. The twentieth-century painter obviously cherished the compositional grace and color balance of the seventeenth-century oil. In this portrait of the artist's second wife and their children, the domestic subject, the powerful embrace, and the intricate structure of curves all suggest the strength of family links. Mme Rubens in her great plumed hat, and their good-looking son and daughter, suggest lives of perfect health and order.

Whether it was during the six months spent in Chessy, the four months in the mountains, or the two months in Paris, Laurent and Mathieu always shared a room until they reached the ages of eighteen and

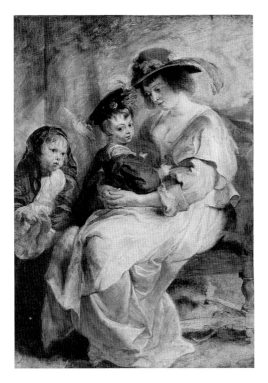

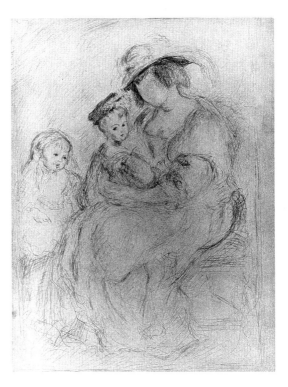

PETER PAUL RUBENS
Helena Fourment and Her Children (1636)
Oil on panel, 113 × 82 cm (44½ × 32¼″)
The Louvre, Paris

Sketch of Rubens's *Helena Fourment and Her Children* (c. 1928)
Pencil, 33.2 × 25.8 cm (13 × 10¼″)

Cécile in Her Hat (1925)
Oil on canvas, 36 × 26.5 cm (14¼ × 10½″)

Laurent on His Rocking Horse (1927)
Oil on canvas, 100 × 81 cm (39½ × 32″)
Collection Cécile de Brunhoff

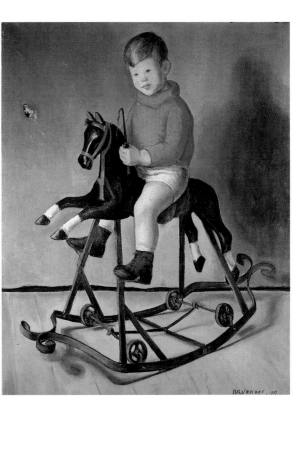

Cécile and the boys in Blonville, 1928

Jean in Vermala, winter, 1930–31

Cécile in Montroc, summer, 1930

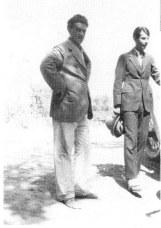

Mio (Émile Sabouraud)
and Othon Friesz, 1924

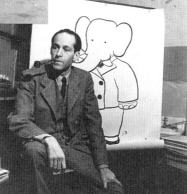

Jean, c. 1934.
Copyright Photo Schall, Paris

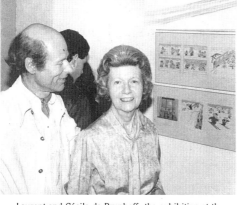

Cécile and the boys in Vermala,
winter, 1930–31

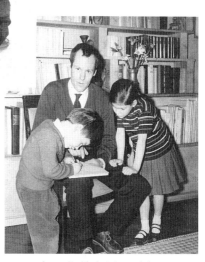

Laurent and Cécile de Brunhoff, the exhibition at the
Marais, 1981. Photo Anne de Brunhoff

Laurent with Antoine and Anne,
early 1960s

seventeen respectively. They got along well. But like many siblings close in age they developed opposite personalities. Like his father, Laurent was strong and quiet, a dreamer who often preferred to be alone. Today he characterizes himself as having been "a bit remote, aloof, and shy," while Mathieu was quite witty, livelier and quicker than he was.[4] Laurent was the better athlete; Mathieu, less tough physically, was more of a talker, full of stories and ideas for pranks. It was Mathieu who got Laurent to throw a cat in the air to see if the animal would really land on his legs. (The poor creature's consequent death still haunts both of them.) Mathieu was often restless; Laurent, who loved to spend time drawing, was never bored. What managed to engage Mathieu above all were practical things, like insect life. Today he is a pediatrician. That profession and Laurent's have kept the experience of childhood pivotal to their adult lives.

The older members of the family were to their young eyes a bit like Sèvres figurines: beautiful, unblemished, and more for observation than intimacy. Laurent's descriptions of them today center on the overall impressions people gave, on appearance, generally with proportions first. "Mother was very slim and elegant . . . and beautiful, her brown hair always pulled tightly back in a chignon. She never shouted or seemed angry, and was always quite reserved. In a way it was surprising, because her mother, whom she adored, was from Bézier in the south of France, and was more hot-blooded." Cécile apparently resembled her distinguished father from Nantes, in the west; he was pleasant and kind, but above all strict and controlled.

Jean de Brunhoff's relatives were quintessential Parisians. Jean's sister Cosette, the oldest of his siblings, was, according to Laurent, "a noticeable person, big and tall, with a great big head, a striking face, and very blue eyes; at the same time very calm and slow." She and her husband, Lucien Vogel, were imposing to the point of being intimidating. Lucien, a major figure in the world of fashion journalism, was the publisher of *Vu* (a photo magazine similar to what *Life* would become in the United States) as well as a director of the branch of Condé Nast called Jardin des Modes. Tall and broad, with a reddish complexion and blue, pop eyes, he had an unforgettable presence. The Vogels lived in a big house in the woods on the west side of Paris; Laurent remembers them there as a striking couple, Lucien always talking with great animation. Leftist but anti-Communist, he typified the wealthy intelligentsia of the era.

Next in line came Jacques, who worked with Maurice de Brunhoff in publishing and edited *Le Décor d'aujourd'hui*. Then there was Michel, editor-in-chief of French *Vogue,* quite different from the others, small and round, with brown eyes. Warm and funny, he was beloved by many. Jean, Michel's junior by eight years, was tall and very handsome. Most often dressed in casual tweed suits, he was quiet—cheerful and optimistic, but never demonstrative, the ultimate aristocrat. And like most aristocrats, he loved to play. When there were costume contests at the hotels where the family skied, Jean de Brunhoff was not to be outdone, often taking first prize for his fantastic hats. On one occasion in Vermala, he costumed himself in a horse's head he had made; a friend, bent over in a right angle, walked behind him, with a blanket draped over to create the illusion of the horse's body. Cécile, in a long dress and top hat, marched at their side as the animal trainer. It seems natural enough that in time the two of them would be elaborating tales about elephants dressed as human beings.

The pages of the Babar books are an invaluable memoir of Jean de Brunhoff's essential nature.

When Cécile de Brunhoff invented the tenacious, resilient Babar and introduced him to the pleasures of the world, she was dealing with familiar territory; her protagonist may have been a childish elephant, but his story had the charm her husband gave to everyday existence. Babar's ability to blend fun and duty was fundamental to Jean's being. And when Jean elaborated on his wife's tale in *The Story of Babar* and the six subsequent volumes, he captured the courtly, moral behavior that was at the core of his own existence. By nature as well as breeding, he favored gentle manners and kindness in conjunction with deep intelligence, and so it was perfectly natural for him to imbue his heroes with these qualities. He made Babar's wife Celeste as outgoing and as ingenuously stylish as his own wife was—and gave her a similar name. Celeste was not, however, a sufficiently strong female character, so Jean added the Old Lady. Cécile de Brunhoff had no such person in her version of the story, but Jean may well have needed her as a further means of integrating into the tale the sort of generosity and tenderness he perpetually witnessed in his wife.

Jean's forthright yet delicate watercolors have both the easy tone and the savoring of nuance that were key to him and Cécile. The art joins spontaneity and discipline, abundance and control—the values intrinsic to their life. The paintings are both intelligent and funny. Their style harmonizes with the storytelling; everything is simple and direct. There is no embellishment in the writing nor ornament in the art—except when it is the ornament intrinsic to the subject matter. Characters and scenes are set down in a swift and natural way. Like the succinctly told tales, the crystalline visual images give the impression of having been made quite effortlessly. An admirable, unconceited confidence lies underneath. The voice is buoyant but under check, the euphoria present but restrained. With brush and words, de Brunhoff becomes wry and jocular or straightforward and factual at will. He alternates anxiety and ecstasy. Nonetheless it is all very compact. You get the message—of both the visual images and the plot—without an iota of doubt. At the same time, there is ample refinement. The voice of the writing and the surfaces and compositions of the watercolors are gentle and artful.

The French, at the turn of the century, had practically reinvented the illustrated book. Along with the work of André Helle, Edy Legrand, Boutet de Monvel, Felix Vallotton, and Pierre Bonnard, de Brunhoff shared a freedom and charm, a freshness of vision that captivates and takes the breath away. Like an extravagant piece of poetry, the interplay between few words and many pictures, commonly called the picture book, is a difficult, exquisite, and most easily collapsible form that few have mastered. The successful results are so ingenious and profound that they should rightfully take their place with comparably sophisticated "grown-up" works of art.

Jean de Brunhoff was a master of this form. Between 1931 and 1937 he completed a body of work that forever changed the face of the illustrated book.

Maurice Sendak[5]

It is not surprising that Cécile de Brunhoff's thoughts turned to the possibility of a jungle creature strolling down the streets of Paris. Why not have an elephant don evening clothes in an era when transformation through dressing up was the rage? Costumes and clothing—pivotal to all of the early Babar books--were the preferred means of entering one world and leaving another behind. In the year that Babar was conceived, the great American chronicler of Paris life, Janet Flanner, wrote that "the

June season of 1930 will be remembered as the greatest fancy-dress-ball season of all years."[6] Jean and Cécile de Brunhoff were aware of such events even if they never left the quiet rooms of Chessy or the small flat in the sixteenth arrondissement to attend them. "In Paris, where entertaining has long been an art—and was, as much as war or wit, one of the civilizing French forces in Europe— parties have always been taken seriously, even by those who weren't invited. . . . The 1930 Parisian parties—by being unusually frequent, fantastic, and mostly foreign, were remarkable for representing the true spirit of their time."[7] Women dressed as men, whites as blacks. At a party given by the dressmaker Jean Patou, where each twig in the garden was wrapped in silver paper, three lion cubs were given as grab-bag prizes. At a masquerade many of the guests appeared as shepherds and shepherdesses, and one came as a wolf in sheep's clothing. That same season, Josephine Baker's new Casino show featured trained pigeons, a live cheetah, and a gorilla who rescued her from a typhoon. It was quite natural to have an elephant go to the city, dine in a good house, and dress like an upper-class human. Jungle creatures had never before been so at home in urban settings.

At the Cirque Medrano that year there was a "pretty young Texan (whose real name, we understand, is Mr. Vander Clyde)"—Janet Flanner again—"who performs his high wire and trapeze stunts dressed in female attire." His name was Barbette. He wore "fifty pounds of white ostrich plumes."[8] The crowd who watched him were the "*tout Paris* audience such as formerly gave color to the Cigale and chic to the Diaghilev Ballet"—where the programs were published by Maurice de Brunhoff. In the same year that a male named Barbette was twirling on the high wire in fifty pounds of ostrich feathers, at a circus that the de Brunhoff family visited often, an elephant named Babar seems entirely appropriate.

Cécile de Brunhoff generally read to her children pretty much what most French parents were reading at the time—the Brothers Grimm, Hans Christian Andersen, La Fontaine, Rabier, Perrault, Beatrix Potter, and A. A. Milne (Mathieu named all of his teddy bears "Pooh")—but on this occasion she made up a story. It was something she had never done before, and would never do again. Her version of the elephant tale was quite short and simple:

A little elephant was happily playing in the jungle when a hunter shot his mother. The scared elephant ran away to a town where he found a lost purse in the street, enabling him to go to a large shop where, after playing with the elevator, he bought some clothes. Having thoroughly enjoyed himself in the town, he was persuaded by his cousins to return to the jungle.

Cécile eventually helped Jean invent a better ending for the story, when he said that her tale hadn't gone far enough. But she told him that from that point on it was all up to him. He could do more books if he wanted, but she had lost interest. When *The Story of Babar* was published and Jean proposed to Cécile that she should be listed as one of the authors, she said no. She viewed her role as far too minor, and not to be continued.

As for Jean de Brunhoff, the stories he most liked to tell his sons were based on the *Iliad* and *Odyssey,* where some of the professions and names in the Babar series originated. The plot of *The Story of Babar* has, in fact, the scope of an odyssey, one that became fuller and richer in his reworking of his

wife's version. In a direct line, the tale follows a course of straightforward encounters with very good good and very bad evil. The ups and downs and the simplicity of their telling are in the manner of many fairy tales. Like the best of such tales, *Babar* and its sequels evoke emotions familiar to virtually everyone.

The Story of Babar begins, "In the great forest a little elephant is born. His name is Babar."⁹ Simple enough: a sequence of facts. The illustration, for which the original watercolor still exists, is grasped with equal ease. It is a rich image of maternal nurturing; the baby Babar is rocked in a hammock by his mother, who uses her trunk. From the start, elephantine and human life are wittily intertwined. We'll never be quite certain which species we're dealing with, and it's the anthropomorphism of the huge smooth elephants that gives these books much of their hold on us.

The hammock scene reflects a blend of consummate artistic skill and childlike, almost primitive freshness. The style gives the appearance of both effortlessness and knowledge. It has the naturalness that has made other ingenuous sophisticates—Henri Rousseau, Gabriele Münter, Alfred Wallis—the envy of their compatriots. De Brunhoff painted by instinct. He emerges the master of poignant summation. Well-being, plainly articulated, pervades. Here are quintessential palm trees, the mark of tropical luxury. Masses of red flowers and a single butterfly establish the opulence of earthly life. Entering the story, the reader—or child to whom the story is being read—leaves all haze and incertitude behind.

The world today is loaded with people who can hardly wait to describe their initial encounter with the Babar books as if they are recounting a first love affair; what seduced them most of all is the richness and vitality of the images. That opening page of *The Story of Babar* is a case in point. The central figures, drawn in the briefest possible shorthand, are as tender as many a Renaissance Virgin and Child. One large undulating curve envelops them. It follows the profile of the mother's back, moves along the top of her head and trunk, and continues along the broad sweep of the strung hammock. That organic, unifying line echoes the warm, soothing forms of wombs and nests. The palm leaves play further on these shapes; rather than being spiky, harshly angular palms, most of these trees have been rendered unusually soft and friendly, like small children's drawings of stars.

The major curve of mother and baby leads the viewer from the dominant foreground figure into the background. This device suggests one of Jean de Brunhoff's greatest skills: his ability to organize the picture space with clear distinction between near and far. Not only did he articulate position precisely; he also differentiated between the well-formed mother, sturdily dexterous and in control of what she is doing, and the delightfully unformed baby. The limp-limbed Babar, practically amorphous, appears quite helpless. De Brunhoff's drawing technique renders the baby elephant as someone who could not yet possibly take care of himself.

Consider, then, some of the details. There are the two small orange-red birds. De Brunhoff positioned them between two palm trees, where they provide the perfect accent in the composition. Rather than fly upward or away, they are in stasis, fixed in play with one another. They hover as if about to kiss. Their posture binds them indubitably to one another; whether they are teasing or desperately pining, they partake of a heavenly union. This camaraderie is achieved with nothing more than bold outlines and the sparest notations of eyes and beaks on flat bodies of undifferentiated color. A large

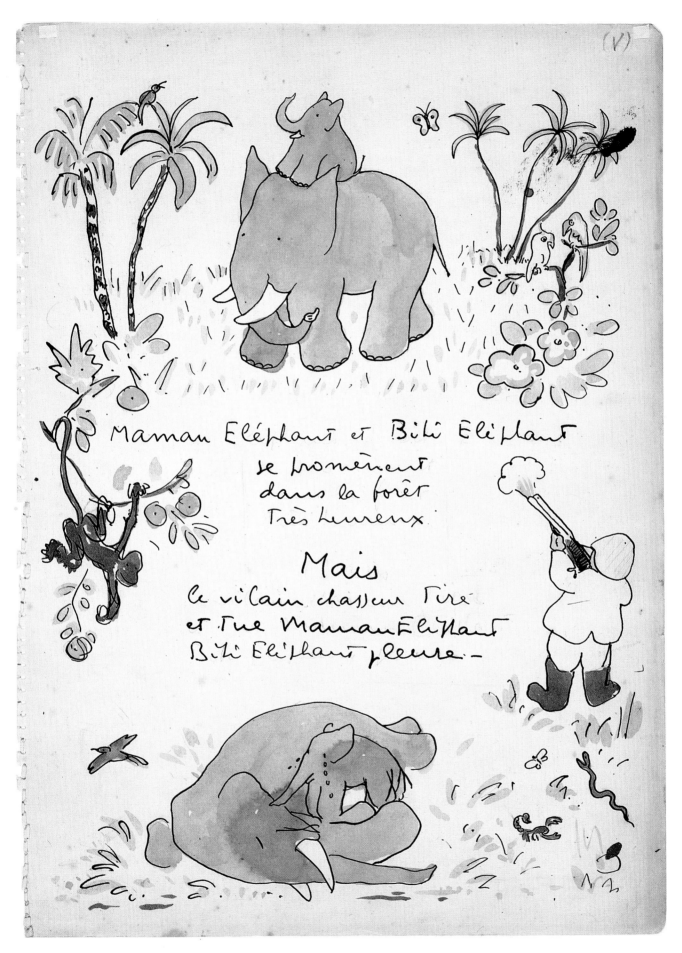

Maman Eléphant et Bibi Eléphant
se promènent
dans la forêt
Très heureux.

Mais
le vilain chasseur tire
et Tue Maman Eléphant
Bibi Eléphant pleure —

THE STORY OF BABAR (1931)

The Death of Babar's Mother (study)

Ink and watercolor, 37 × 27 cm (14½ × 10½")

THE STORY OF BABAR (1931)
Sketch for *The Death of Babar's Mother*
Pencil, 33 × 26 cm (13 × 10¼″)

26

part of de Brunhoff's success is the result of his ability not to present too much information. His shorthand evokes all of the complexity of real birds.

The mind craves summaries, and this picture contains many. Lean, downward strokes make Babar's sleepy eyes; a pert dot gives his mother her alert gaze. The conciseness of such messages is what the art historian E. H. Gombrich pointed out in his seminal *Art and Illusion*. For Gombrich, de Brunhoff's work "demonstrate(s) the final distillation of expression in the simple work of illustrators or of designers of children's books."[10] What impressed Gombrich is the expressiveness of the faces, given the total economy of detail. "Brunhoff with a few hooks and dots could impart whatever expression he desired even to the face of an elephant, and he could make his figures almost speak merely by shifting those conventional signs which do duty for eyes in children's books."[11]

Not only did Jean de Brunhoff illustrate his wife's invented character here, but he also named him. The bedtime story had simply referred to an unnamed "Bébé éléphant." No one is certain of the origins of "Babar." The name may simply have come out of the air. It may unintentionally have been a blend of "papa" and "bébé," not unsuitable given that in the course of the stories Babar is both father and child. It may also have been influenced by an Indian word, because many names in India have the same termination in *-ar.* Although Laurent doubts that his father ever saw the actual name "Babar," and Cécile feels that Jean was completely unaware of Eastern sources, the derivation would be appropriate. The *Babur Nama,* sometimes translated as the *Babar Nama* — is the Indian "Book of Kings" devoted to a noble descendant of Timur Lang, the fifteenth-century conqueror of India. Babur or Babar, who in many ways represented the entire Indian nation, was a heroic and regal figure.[12] In any event, the ambiguity and timbre of the name, regardless of the source, is a big part of the success of the books.

The art of *The Story of Babar* maintains the graphic vividness established on that opening page. In an ensuing scene of Babar's youth, elephants frolic in a marshy pond and shower themselves from their trunks; they also play ball, picnic, and give rides to monkeys. The line, sure yet jocular, establishes telling postures for each elephant and lends sweep and grandeur to the distant mountains. When the jungle paradise is suddenly torn asunder by evil, the gun blast that kills Babar's mother has a scorching angular red as disruptive as the event itself. The painting of the dead elephant is as poignant as many of Picasso's studies of dead Minotaurs (also of the 1930s.) The rendering of the tear drops of the baby at the side of his mother's corpse, made in simple, cartoon-like style, communicates directly and saliently. And the scene is evidence of de Brunhoff's talent for organizing deep spaces and for articulating details like the scrub brush and flowers, as well as the monkeys, parrots, and butterflies. This richness of earthly settings is a big part of the allure of all of the Babar books.

An early watercolor sketch remains that has, on a single page, the hunter scenes that eventually ended up opposite one another. This is from a preliminary version of the book that de Brunhoff made prior to the one he sent to the printer. There is additionally a pencil sketch that may have been de Brunhoff's very first rendering of both the illustration and the text. Both have the elephants' positions reversed from the way they finally appeared when de Brunhoff changed the composition to accommodate the new two-page arrangement by balancing left and right. In the top scene, we feel — even more than in the final version — the support, emotional as well as physical, that Babar's mother gives him.

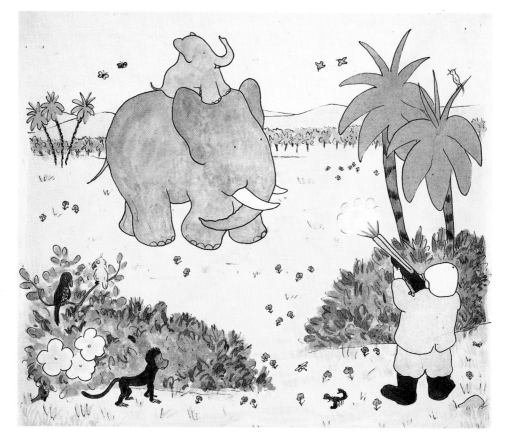

THE STORY OF BABAR (1931)
The Death of Babar's Mother (final version of left-hand side)
Ink and watercolor, 22 × 25.5 cm (8¾ × 10″)

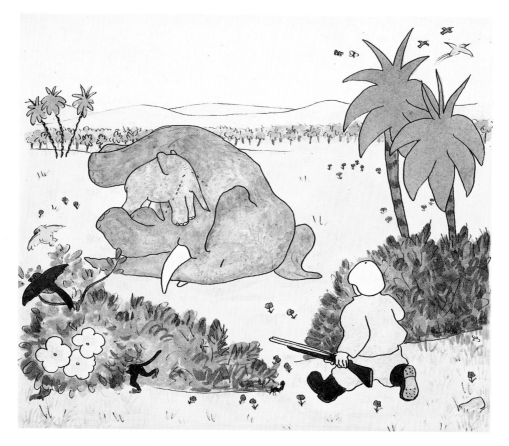

THE STORY OF BABAR (1931)
The Death of Babar's Mother (final version of right-hand side)
Ink and watercolor, 22 × 25.5 cm (8¾ × 10″)

Her strength and solidity are emphasized by the inward curve of her trunk, with Babar's carefree attitude accentuated by the playful upward curve of his. The dancing shape of his back is formed by a lighter curve than hers is. Painted a paler gray than his mother, the baby is the image of innocence.

Throughout his books, de Brunhoff uses the precise nature of stance to great effect. He pays keen attention both to the way his figures hold themselves, and, accordingly, to the weight of his line. The hunter's posture epitomizes an ugly confidence. Short and squat, with his oversized boots, he signals brutish violence. In the shooting scene, the kick of his gun has forced him backwards, but those hideous boots keep him anchored; in the next scene their spikes are visible. De Brunhoff establishes malevolence as surely as he conjures bliss. By keeping the hunter faceless, he makes him painfully subhuman and depersonalized.

In this preliminary image of the dead mother elephant mourned by her baby, all lines move downward and hug the horizon. The trunks have gone totally limp, one through death, the other through grief. We feel—and this is true in the final version as well—that de Brunhoff has let his wrist go flaccid. The pen line has, appropriately, lost its look of bravura and assurance. Artistic style augments emotion to considerable effect.

Cécile de Brunhoff has no idea why she began her story of the baby elephant with his mother's death. She may have been working out one of a parent's deepest fears—of dying and abandoning her children. Her solution to the imaginary tragedy was reassuring not only for Laurent and Mathieu, but also for her. As a mother nurturing a sick child, however minor the infirmity, Cécile may have been anticipating that distant moment when separation from her would be essential to his emergence as a full person.

Parental death often plays a major role in children's stories. In Felix Salten's *Bambi,* published in 1923, a baby animal's mother is shot by a hunter; here too the orphan ends up marrying his cousin, as will Babar. The similarities are entirely coincidental, however. The de Brunhoffs were unaware of *Bambi;* until recently, Laurent thought it had been conceived in the 1950s by Walt Disney. And while in *Babar* the killing by a hunter is largely a device—the essential precursor to the rest of the action—in *Bambi* it is the focal point of the entire book. Salten presents humankind as almost entirely destructive, scarcely to be emulated as it is in *Babar.*

Bruno Bettelheim, the psychoanalyst whose interpretations of fairy tales have transformed for all times adult views of children's literature, addressed the significance of parental death in a way that applies to Babar's experience.[13] "Many fairy stories begin with the death of a mother or father; in these tales the death of the parent creates the most agonizing problems, as it (or the fear of it) does in real life."[14] The crisis forces the bereaved child to emerge fully. The successful facing and handling of this tragedy is the basis of a healthy psyche. "Psychoanalysis was created to enable man to accept the problematic nature of life without being defeated by it, or giving in to escapism. Freud's prescription is that only by struggling courageously against what seem like overwhelming odds can man succeed in wringing meaning out of existence.

"This is exactly the message that fairy tales get across to the children in manifold form: that a struggle against severe difficulties in life is unavoidable, is an intrinsic part of human existence—but that if one does not shy away, but steadfastly meets unexpected and often unjust hardships, one masters all obstacles and at the end emerges victorious."[15] Babar's reaction to his mother's death is to

run away from the jungle and go to "a town" that is very much like Paris. He quickly flourishes there. That resilience paves the way for a sequence of personal triumphs.

The child reader, writes Bettelheim, "needs ideas on how to bring his inner house into order, and on that basis to be able to create order in his life. He needs . . . a moral education which subtly, and by implication only, conveys to him the advantage of moral behavior."[16] The Babar books provide that education. Moral instruction, as much as entertainment, was clearly one of Jean de Brunhoff's primary goals. Time and again, he gives evidence that perseverance and gentleness prevail. The proper balance of confidence and humility repeatedly leads to triumph. The points are clear. And good accoutrements of living—especially stylish clothing and fine food—help immeasurably in softening life's blows.

A child wants to feel that he can cope with any loss. His greatest fear is that his parents will die, his greatest need his ability to survive that abandonment. Whatever happens to Babar, from the blast of that shotgun on, he emerges victorious. His mother's murder isn't just a reality which Babar handles adequately; it is the event that provides him with the opportunity to grow. Without it, there would be no story and no reason for Jean de Brunhoff's paintings of the good life in Paris and its surroundings. "Only by going out into the world can the fairy-tale hero (child) find himself there," writes Bettelheim.[17] Once launched from the jungle, Babar acquires worldliness. He learns how to handle himself in all situations. He becomes either adventurous or stolid as befits the situation. And having dealt with evil and adversity so successfully the first time, he always continues to do so.

Babar's reaction to his abandonment is completely consistent with young children's means of handling such a tragedy. They don't want their own living to be interrupted in any way, and so they immediately grasp onto life wherever it is to be found, even if that means leaving the house where one of their parents is being mourned and going to play next door. The concept of death, difficult to fathom at any age, is beyond cognitive reasoning of children younger than the age of twelve. Their instinct is to keep on growing and absorbing life, allowing sadness and grief to seep in only to the degree that they can bear.[18] I once saw a six-year-old after his mother's funeral service playing happily on the lawn in front of the chapel; he stalled joining the procession to the cemetery for as long as possible. I know another little boy whose mother died when he was four; the child said to callers, "My mother just died, and I can do anything I want." Everyone was chilled except for his father, who knew that this was the boy's only means of coping. What strikes some readers as cold in *The Story of Babar* is in fact a key to its celebration of the survival instinct.[19] Babar will live as well as he can. His apparent indifference to his mother's shooting is a by-product of the essential drive to see beauty and continue living no matter how tragic the past.

Babar's success in Paris comes, thanks to "a very rich Old Lady," who spots him wandering near the Place de l'Opéra. She "understands right away that he is longing for a fine suit. As she likes to make people happy, she gives him her purse." Eventually she takes him into her house and becomes his patron forever.

The role of the Old Lady raises all sorts of questions. Having added her to Cécile's original tale, Jean partially modeled her on his wife. Mathieu de Brunhoff says that the Old Lady's Pinocchio nose in no way resembles his mother's, but her chignon and hats were indeed Cécile's. On one level, the two women were virtually identical: the Old Lady is very much a maternal figure, whose role is to provide

the younger generation with worldly amenities. But she is also something more. In a way her presence in the Babar books likens them to every French tale in which a young man from the country has a liaison with an older, more worldly woman. Babar is a kept man, the Old Lady his contented provider.

The Old Lady has some similar functions to Aunt Léonie in *Swann's Way* by Jean de Brunhoff's beloved Marcel Proust.[20] Léonie—whom Proust calls his great-aunt, but is in fact his grandfather's second cousin—symbolizes worldliness and the old-fashioned way of doing things. She is notable both for her accoutrements and for the rules of behavior to which she adheres. She is a link to attitudes and tastes that might otherwise be unknown to the younger generation. Further, both the Old Lady and Léonie are easier to deal with than one's mother. They can be taken for what they are and don't have the power to intrude on Babar's—or Marcel's—psyche. Their flaws have no lasting effect.[21]

One of the ways in which the Old Lady is, of course, in part a substitute mother is that she eases Babar's transition from having parents to being alone. The way she does this makes her like a character from a child's dream. She gives him whatever he wants. My younger daughter, when hearing *The Story of Babar* at the age of five, asked if this meant that Babar could collect more candy at Halloween than any other child in history and still ask the Old Lady for bubble gum and receive it from her.[22] The Old Lady symbolizes many people's dream parent, whatever form that fantasy may take. She provides total devotion and material opulence without imposing any demands.

This will be her role throughout the books of both of the de Brunhoffs. When Babar marries, the Old Lady doesn't express a single opinion or bit of jealousy; she just helps out all she can. In *Travels of Babar*, she takes the newlyweds to a good ski resort to help them recover from their ordeal with the circus. When they take her back to Celesteville, she entertains the younger elephants by telling stories, playing the phonograph, organizing hide-and-seek games, and patiently teaching them arithmetic; she never loses her patience, and is endlessly willing to provide amusement. It would be hard to dislike her. She isn't glamorous enough for anyone to feel jealous of her. She doesn't impose herself as a parent or a mistress would. In Laurent de Brunhoff's books she is often a refined and unassuming presence at Babar's side, doing no more, for example, than preparing the buffet and "a spectacular birthday cake" at a party given for Babar's fourth child, Isabelle, who is born in 1987 (*Babar's Little Girl*). For like everyone else in the series, the Old Lady never ages or dies. She may be old, but she never grows the least bit more frail than she is at the start.

Under the Old Lady's tutelage, Babar goes from being four-footed to two-footed. Having become more human, he worries about what he wears, and takes to preening. He gets an enormous boost looking at himself in the mirror in the right new clothes. Babar has acquired many of the tastes central to the city that has long been the fashion capital of the world and where surfaces and presentation matter deeply. The acquisition of objects is one of the most significant events in his humanization; its importance is emphasized by the words "Babar then buys himself" being in the largest script in the entire book. Babar's experience is many people's dream: a cost-free shopping trip to a fine store that has just what you want—in the right color and your exact size. No matter if that size is "elephant."

The style of the vignettes from Babar's buying spree makes them both credible and funny. Simplified in technique and reduced in content, these drawings drive home their point. De Brunoff's line is almost

une
chemise
avec col
et
cravate,

un
costume
d'une
agréable
couleur
verte,

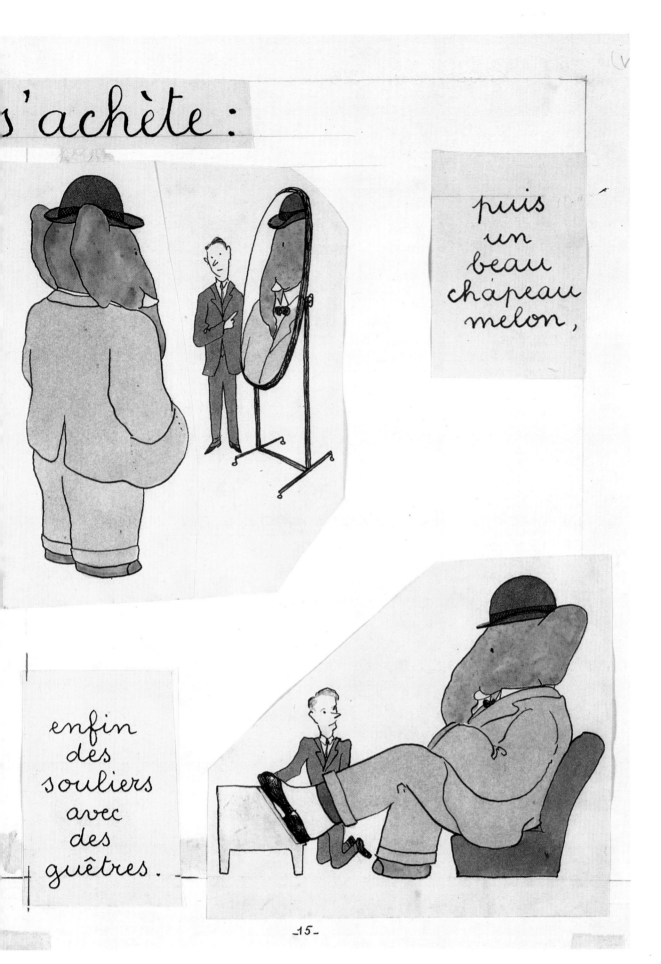

s'achète :

puis
un
beau
chapeau
melon,

enfin
des
souliers
avec
des
guêtres.

15

THE STORY OF BABAR (1931)
"Babar then buys himself"
Ink and watercolor, 29.5 × 47 cm (11½ × 18½")

childishly forthright—the deliberately clumsy directness is a vast part of its appeal—and it makes its subject palpable. These scenes convince us that there is very little in urban life that he could not show accurately and humorously. The spread of four illustrations captures the appurtenances of a fine haberdashery in a way that enables aficionados of such places to smell their special leathery aroma. We see the end of a well-polished wooden desk, an oval mirror (another suggestion of Picasso), an elephant-size footrest. The concept of furniture made especially for the trying on of shoes is uniquely human; by making that footrest big enough for an elephant, while keeping the club chair under Babar human-scaled and far too small for him, de Brunhoff marries his two worlds. That footrest is a great touch; it diminishes the salesman to the size of a dwarf, which is perhaps exactly how many people in such positions feel when assisting their grandest customers. By angling the salesman's mouth and nose, placing his eyes asunder, and reducing his chin to mush, de Brunhoff puts him in a role of frantic servility. Babar, by contrast, epitomizes ease and repose. He rests comfortably on what is undoubtedly the softest, most buttery leather. We intuit the quality of the leather just as we could hear the singing of the two small birds in the opening scene.

As *The Story of Babar* moves on, Babar is easily swayed by narcissistic, hedonistic living. His mother may have been shot only a few days before, but he sits with utmost contentment having his picture taken in his new bowler hat. He has left the actual jungle and with it the jungle of emotions. Worldliness comforts him. His vast elephant bottom is now supported by the most delicate Directoire chair (just like those at Chessy). Exoticism is safely confined to the Oriental rug on which Babar rests his spat-covered shoes. If he was raised under real palm trees, now the only visible palm is in an ornate porcelain pot atop a fancy stand. The scene comments on the integration of both Eastern culture and the jungle into urban civilization.

A quick preliminary sketch for this scene shows de Brunhoff's feeling for twisted forms and for how they can give a setting pizazz. He transmits the full impact of the ornamental filigree on the chair and of the stand under the potted palm, which looks like a belly dancer in full swing. The artist's extraordinary dexterity and command are clear in his speedy rendering of the camera on wobbly legs. Seemingly dashed off in an instant, the drawing not only establishes these objects, but also captures Babar's elegance and pleasure in himself. In the final version, de Brunhoff's skills as a draftsman are especially striking in the folded black cloth on the back of the camera—a difficult object to illustrate. Its surface of black lines crosshatched against the gray background plays well with the vertical black pinstripes on the photographer's gray suit. De Brunhoff didn't just draw those pinstripes. He drew the message of pinstripes. In his hands they convey the essence of dressing up—the means of suggesting seriousness and status—and the blessed silliness of "civilized" life.

Babar by now is not only even more human than before, but also exceptionally savvy by human standards. (Cécile de Brunhoff gave her hero a good start on intelligence by making him an elephant, one of the smartest mammals.) Bettelheim points out that as a general rule "to the child, there is no clear line separating objects from living things; and whatever has life has life very much like our own."[23] Children have few problems imagining stuffed or fictitious animals speaking and comporting themselves very much as people do. At age six, my older daughter instinctively referred to Babar as "the biggest person on the page" in the shopping scenes.[24] Adults, too, are happy to mitigate the

En sortant du
magasin il se
trouve si beau
qu'il va chez
un photographe
pour se faire
photographier

THE STORY OF BABAR (1931)

Sketch for *Babar at the Photographer's*

Pencil, 33 × 26 cm (13 × 10¼″)

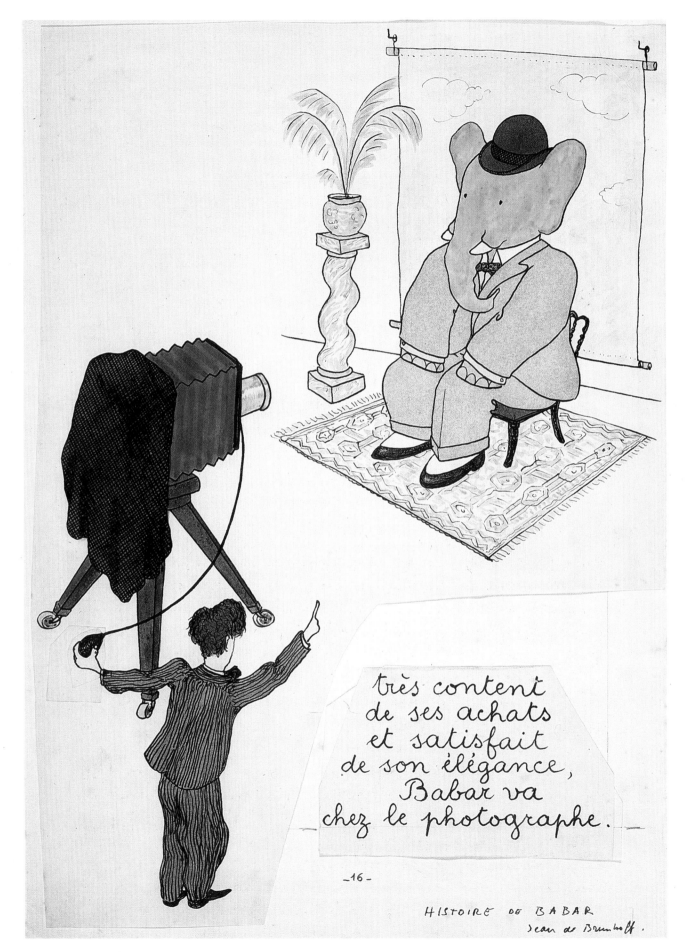

très content
de ses achats
et satisfait
de son élégance,
Babar va
chez le photographe.

-16-

HISTOIRE DE BABAR
Jean de Brunhoff

THE STORY OF BABAR (1931)
Babar at the Photographer's
Ink and watercolor, 35 × 25.5 cm (13¾ × 10″)

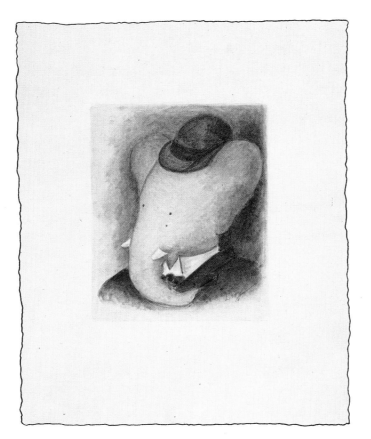

THE STORY OF BABAR (1931)
Babar's Photograph
Ink and watercolor, 24 × 21 cm (9½ × 8¼")

distinction between so-called beasts and our own species. The hard realities of Babar and his family being elephants — and of the other characters in these books being monkeys, rhinos, ducks, and so on — scarcely matter. They become, as much as anything, people who resemble elephants and monkeys. (In France, the recent prime minister Raymond Barre became known as "Babar" because of his looks as well as his name. We all know a lot of Zephirs.) De Brunhoff's characters have the luxury of being able to combine the most amusing aspects of two species at once, as when, for example, elephants dress and dine in grand human style and then shower from their trunks. Their ability to do almost anything and go almost anywhere is part of their magic.

The scene of Babar at the photographer's suggests a lot about *human* nature. Babar's pleasure in his own looks, so soon after his mother's death, epitomizes sentiments intrinsic to most children, who can follow the most miserable tears with immediate consolation in front of the mirror. Moreover, particularly in cities like Paris where fashion is seminal, the abiding pleasure in clothes and looks that pervades the Babar books accurately reflects the way that many people feel and function. The watercolor and charcoal image of Babar's photograph — a subtle grisaille (framed in a mellow ivory yellow in the printed books) — encapsulates contentment and self-confidence. Gussied up with his ridiculous bowler (precisely the circumference of his ears), his wing collar of equivalent value to his tusks, Babar is renewed by the trappings of elegance. Without his mother's death, he would never have

left the jungle. Now he has done more than simply leave his homeland and enter the world of materialism; in reacting to tragedy with resilience, he has gained confidence and maturity.

The role of fashion is another aspect of the Babar books that reflects the world of the de Brunhoffs. One brother of Jean's was, after all, the editor of *Le Décor d'aujourd'hui,* the other the editor-in-chief of *Vogue.* Taste and appearance were an integral part of everyday life. Émile Sabouraud says everyone was expected to look his best, although foppery was as out of the question as a three-day beard. "Jean himself never talked about clothing—but he always looked wonderful. He was so handsome, and naturally elegant, and of course perfectly well dressed, without ever making anything of it."

Babar's odyssey takes him deeper and deeper into the good life. He enjoys a fine meal, a night's sleep in a comfortable Empire-style bed, an exercise session (for which he sports bikini briefs), a bath in a claw-foot tub, and a ride in a spiffy motorcar. The details of that motorcar ride derive closely from the de Brunhoffs' home territory. It takes place along the River Marne, at a spot like those near to the house in Chessy. This scene, rich in details of good Île-de-France living, is like a slightly naive, updated version of Seurat's *Grande Jatte,* exalting the pursuit of leisure (page 42-43).

The Marne scene was painted in an era when automobiles were still an exciting new idea. While Jean and Cécile did not have a car of their own, some of Jean's prosperous siblings did. Jean de Brunhoff gave Babar a dream of a car with whitewall tires and a streamlined hood ornament. But Babar in his car is only part of the story here. What makes this painting wonderful is the richness of life in the countryside. Here Jean de Brunhoff welcomes his elephant hero and his viewers into the world he knows best: rural life in the Île-de-France. Having successfully appropriated the worldliness of Paris—the dark spots on his deep crimson-brown coat and motoring cap suggest a rich brocade— Babar now enters a pastoral paradise. There are birds, a snail, a fish, a beetle, ladybugs, bees lighting on flowers, a butterfly, a grasshopper, roosters, ducks, dogs, cows, a horse, a goat, and human beings engaged in a range of activities. In this modest-scaled watercolor de Brunhoff presents all of our major modes of transportation—a tugboat that pulls a barge on which the laundry hangs out, a train whose passengers can be seen through the windows, a single-engine plane, and a horse-drawn carriage, in addition to the car. He includes a working farm, a red-roofed restaurant, a distant village. There are suggestions of both work and play: a successful fisherman, a balloonist, rowboats, children swimming. And there are myriad types of flowers and trees. This all-encompassing scene is an informal descendant of Jan van Eyck's panoramas and calendar pages from medieval books of hours. It blends solid structure with intense responsiveness and joy, and is a paean to the infinite diversity of everyday pleasure.

The Île-de-France was the home of some of Jean de Brunhoff's exemplars—Pissarro, Sisley, and Monet among them. Like them, de Brunhoff conveyed what the critic John Russell calls the "noble transparency" of the atmosphere there, the sky that is "a great dome of light" and "the air [that] . . . retains . . . a classical moderation of tone."[25] The pure and even sunshine set the tone of existence. The Île-de-France, says Russell, was "one vast national park of fine living."[26] It was also the part of France in which the Guermantes lived, hence a link to that Proustian world sustained so richly by the nuances of dailiness. No wonder that Jean de Brunhoff wanted to offer Babar—and through him the world—its profusion of riches.

THE STORY OF BABAR (1931)
Sketch for *Babar's After-Dinner Talk*
Pencil, 33 × 25 cm (13 × 9¾″)

Before Jean de Brunhoff got down to the details of this scene, he developed the picture as a whole, roughly blocking out the major forms in a preliminary sketch. Drawings of this sort point out that, important as the array of details were, the organization of the space took precedence. Sketching quickly, keeping the forms fresh and alive, de Brunhoff strived for utmost lucidity and won it. Everything had its place in his densely packed picture compositions as clearly as in his life.

After his sojourn in the countryside, Babar returns to Paris. He becomes increasingly worldly. At an after-dinner talk he holds forth on the subject of jungle life; we have no doubt that he speaks with the authority and syntactical elegance of a Sorbonne lecturer. Totally at ease before a gilded mirror and ornate marble fireplace, Babar looks more urbane than many humans, his cutaway and striped trousers far more distinguished than the brown tweed suit of one of his listeners. In the preliminary

sketch that remains for this scene, it is clear that the elephant's assuredness emanates not only from his own pose and bearing, but also from the assuredness of de Brunhoff's style.

Like all good fairy tales, *The Story of Babar* periodically shifts its emotional climate. If Babar initially seems indifferent to his mother's death, he soon cries for her. He begins to miss the great forest and the other animals there. The image of Babar mourning his childhood is loaded with significant detail. The rough English-style check of his smoking jacket is commentary both on the good care the Old Lady has taken of Babar and on the way in which a chosen style gives a person his image. Babar's impeccable nattiness contributes to his bounce and confidence. The amount of white shirt cuff that he reveals— precisely correct by Savile Row standards—makes him so impeccably urbane that his elephant's forefeet, which we now perceive as hands, seem funny. Because aspects of this scene are so plausible, we are more easily moved by Babar's experience. We read the valance and curtains, and shutter hinges and vents so easily that we completely apprehend the setting and believe in what we are seeing. That truthfulness of the physical situation makes us feel the emotional one deeply. This is a remarkable portrayal of convulsive grief. Babar is folded into himself. There is anguish in the compression of head and chest, and helplessness in the hunched shoulders and limp arms. The cartoon-like but weirdly expressive notations of his eyes and wrinkled brow suggest wrenching sadness.

THE STORY OF BABAR (1931)
"He cries when he remembers his mother."
Ink and watercolor, 14 × 19 cm (5½ × 7½")

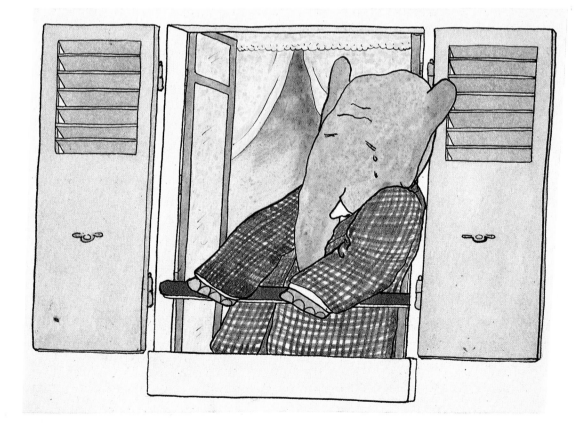

THE STORY OF BABAR (1931)
Sketch for *Babar's Automobile Ride*
Pencil, 27 × 34.5 cm (10½ × 13½″)

Overleaf:
THE STORY OF BABAR (1931)
Babar's Automobile Ride
Ink and watercolor, 35 × 53 cm (13¾ × 20¾″)

Babar's young cousins Arthur and Celeste come to Paris to find him. Babar's very first observation after sighting them is, "They have no clothes on." So, immediately following a splendidly organized reunion scene, he leads his kin to what he has discovered to be one of the essential Parisian experiences; he "hurries off with them to buy some fine clothes." Having raced into Paris on all four legs, Arthur and Celeste quickly stand on two, enormously pleased to be in sailor suit and flowered dress. Soon they are ecstatic at the discovery of eclairs and brioches. Unlike Babar, they entered the story with human names, so it seems natural enough that their humanization takes less time than his.

The mood of the story rapidly shifts again. Jean de Brunhoff balances his plot as deliberately as his picture compositions. In the paintings he plays strong horizontals and verticals against broad (generally elephant-shaped) curves. He measures the yellows against the greens. Similarly, he interjects new emotions where they are needed. We have gone from abject tears to trayfuls of pastry; now

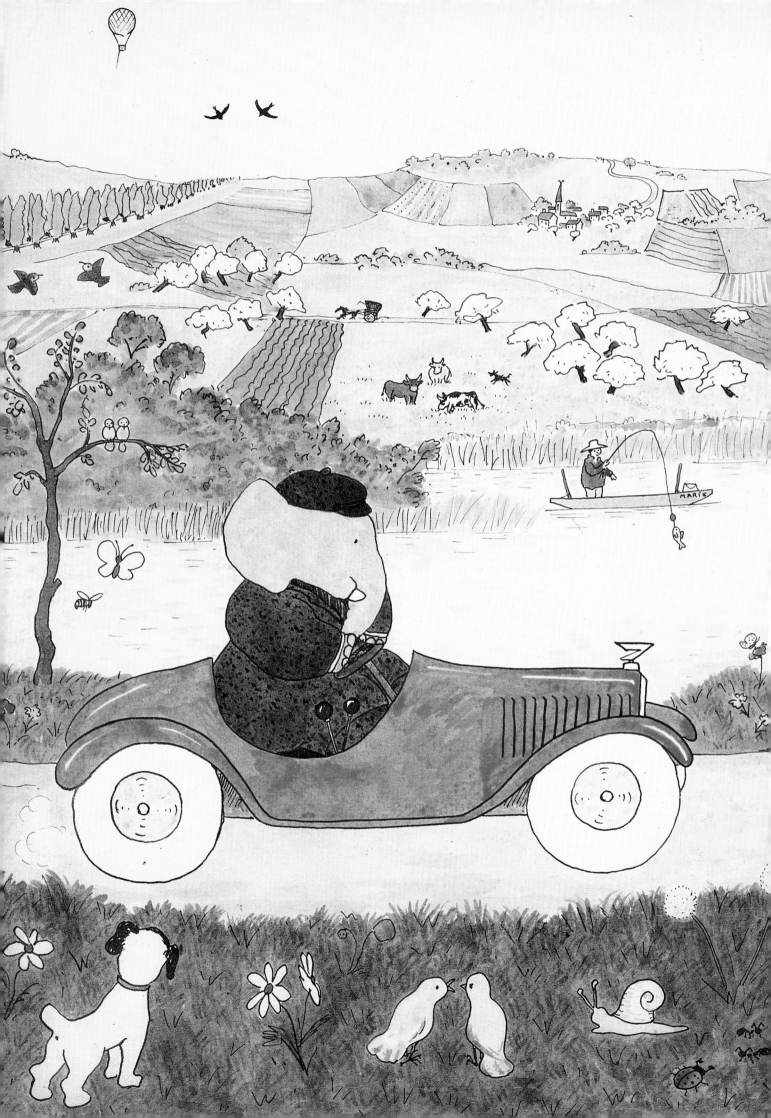

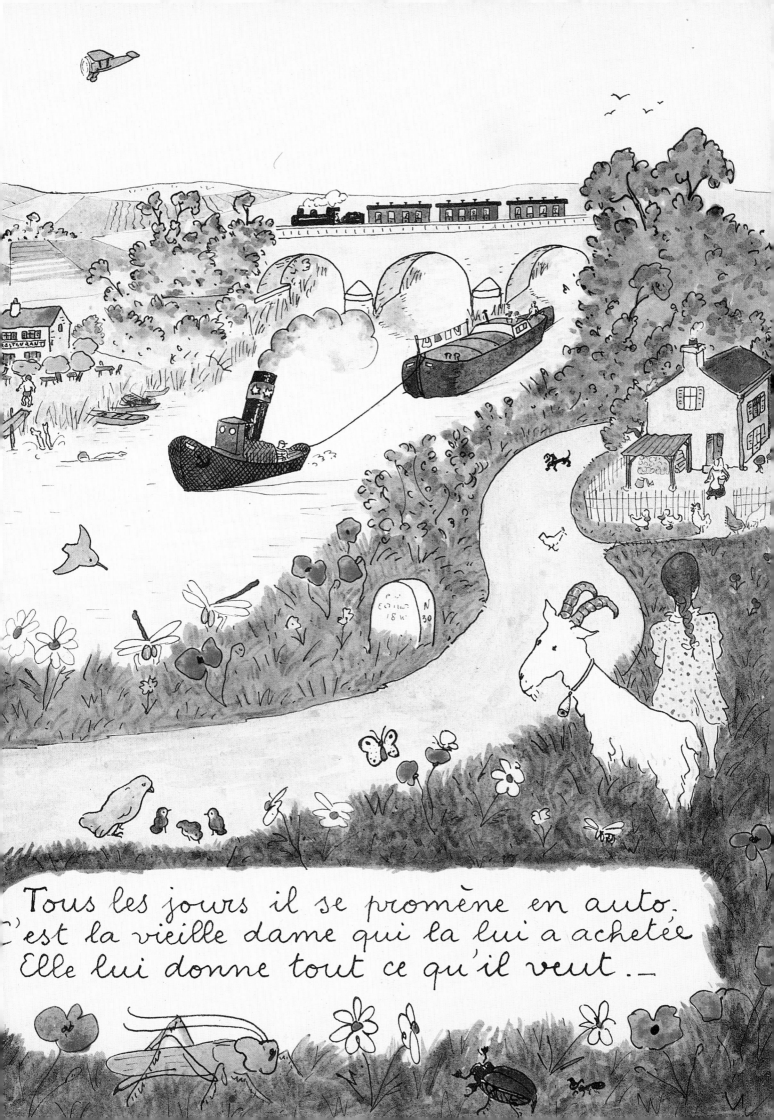

Tous les jours il se promène en auto.
C'est la vieille dame qui la lui a achetée
Elle lui donne tout ce qu'il veut.—

THE STORY OF BABAR (1931)
"Babar kisses them affectionately."
Ink and watercolor, 16.5 × 24 cm (6½ × 9½″)

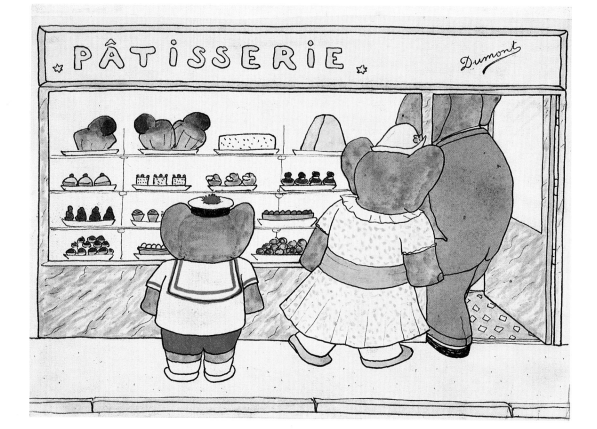

THE STORY OF BABAR (1931)
The Pastry Shop Window
Ink and watercolor, 17 × 24 cm (6½ × 9½″)

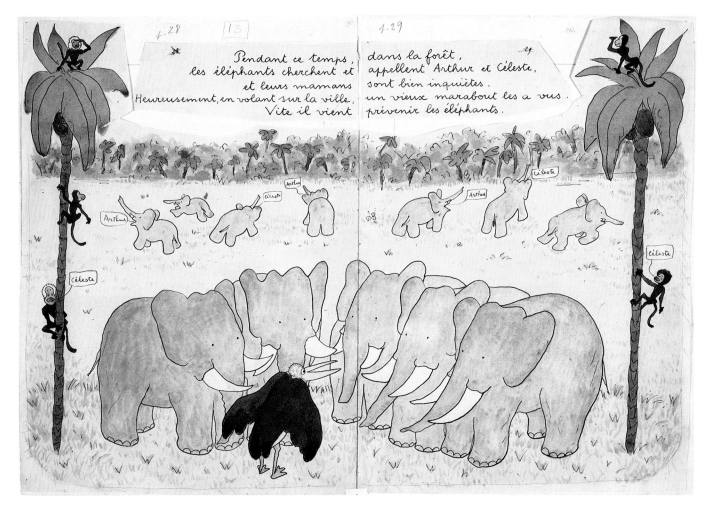

THE STORY OF BABAR (1931)
The Other Elephants Searching and Calling for Arthur and Celeste
Ink and watercolor, 36 × 52 cm (14 × 20½″)

we go from spats to the jungle. On one level it's like real life; anxiety follows hard on the heels of contentment. De Brunhoff returns us to the purely animal world of the great forest, where the other elephants, joined by monkeys and a marabou, cry out for Arthur and Celeste. In this instance only the dark greens of the original watercolor have faded significantly, so it retains much of the vigor that must have been even more pronounced in 1930. Again the art is what gives a moment its resonance: life in the great forest has a tone and scale lacking in Paris. No matter how appealing the nice shoes and good tablecloths have been, the new light and openness are uplifting. And the jungle creatures have a camaraderie that was absent among most of the ill-at-ease human beings. De Brunhoff relates the heads of the elephants at council to suggest their mutual concerns and shared emotions. A warm, broad curve sweeps through the sequence of their trunks and bodies. The wiry forms of the monkeys seem to exist in deliberate counterpoint to the elephants' bulbous shapes. That homogeneity and sense of everyone belonging is in sharp contrast to the screwed-up faces and awkward poses of the disparate shop attendants, dinner guests, and other human characters in Paris.

Arthur's and Celeste's doleful-looking mothers have come to the city to fetch them home. By doing nothing more than properly angling and positioning the mothers' V-shaped eyebrows, de Brunhoff lucidly renders their mix of annoyance and concern. To signal the children's mortification he uses posture rather than facial expression; seen from behind, Arthur and Celeste bow their heads, hunch their shoulders, and let their arms hang limp. The little adventurers in their Paris clothes look tiny and frivolous in the shadow of their mammoth naked mothers. A large part of de Brunhoff's graphic strength rests in his ability to use bold angles to accentuate this sort of contrast. If in his two-page spreads he often uses elaborate frontal symmetry to suggest concord and grandeur, in vignettes like this he employs imbalance and compression to evoke turmoil.

Babar decides to return to the forest with Arthur and Celeste and their mothers. Now master of his own destiny, he is able to take the trappings of his new life with him, yet is free to leave the Old Lady who provided them. He is not insensitive; he regrets their separation and promises a reunion. Yet one could easily be cynical about Babar's treatment of his savior. We are told "he will never forget her," but he is able to leave her as easily as he left the jungle. Mothers and mother substitutes have a rough time in *The Story of Babar.* While the Old Lady stands sadly on the balcony watching Babar and Arthur and Celeste ride off in their sporty car, "there is no room in the car for the mothers, so they run behind, and lift up their trunks to avoid breathing the dust."

Once Babar, Arthur, and Celeste leave Paris, calamity and death reappear. The king of the elephants dies from eating a poison mushroom. But as in all the Babar books, triumph follows disaster. Babar and Arthur and Celeste have a glorious return to the jungle. Cosmopolitanism wins out. The first reaction of the elephants to their arrival is "What beautiful clothes! What a beautiful car!" Babar is elevated by his knowledge of "civilization." Because "he has just returned from the big city, and he has learned so much living among men," he is crowned king.

Like all of Jean de Brunhoff's two-page illustrations, the picture of Babar's return is a well-organized large composition. Complex activity full of cogent details is clearly articulated in a deep space. Having made the action and setting plausible, de Brunhoff provides some amusing touches. There is the pom-pom on Arthur's tam. And in his trunk Arthur holds the rubber bulb of an automobile horn of the sort

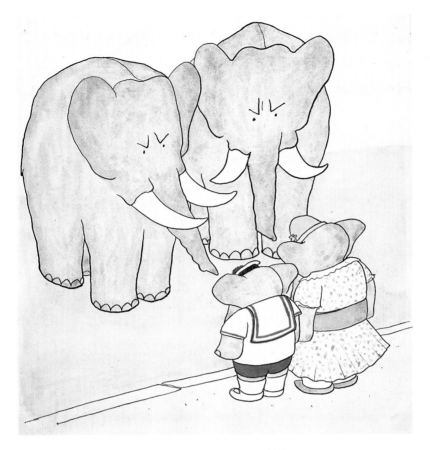

THE STORY OF BABAR (1931)

Arthur and Celeste Scolded by Their Mothers

Ink and watercolor, 26.5 × 25 cm (10½ × 9¾″)

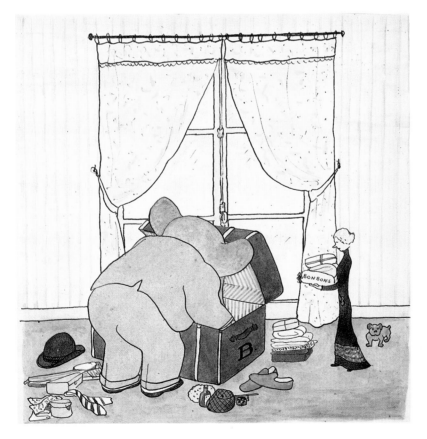

THE STORY OF BABAR (1931)

Babar Packing

Ink and watercolor, 25.5 × 25.5 cm (10 × 10″)

Juste à ce moment ils entendent du bru...
Qu'est-ce qu'ils voient ! Babar qui arriv...
et tous les éléphants qui courent en criant :

« Les voilà ! Les voilà !
Ils sont revenus !
Bonjour Babar ! Bonjour Arthur !
Bonjour Céleste !
Quels beaux costumes !
Quelle belle auto ! »

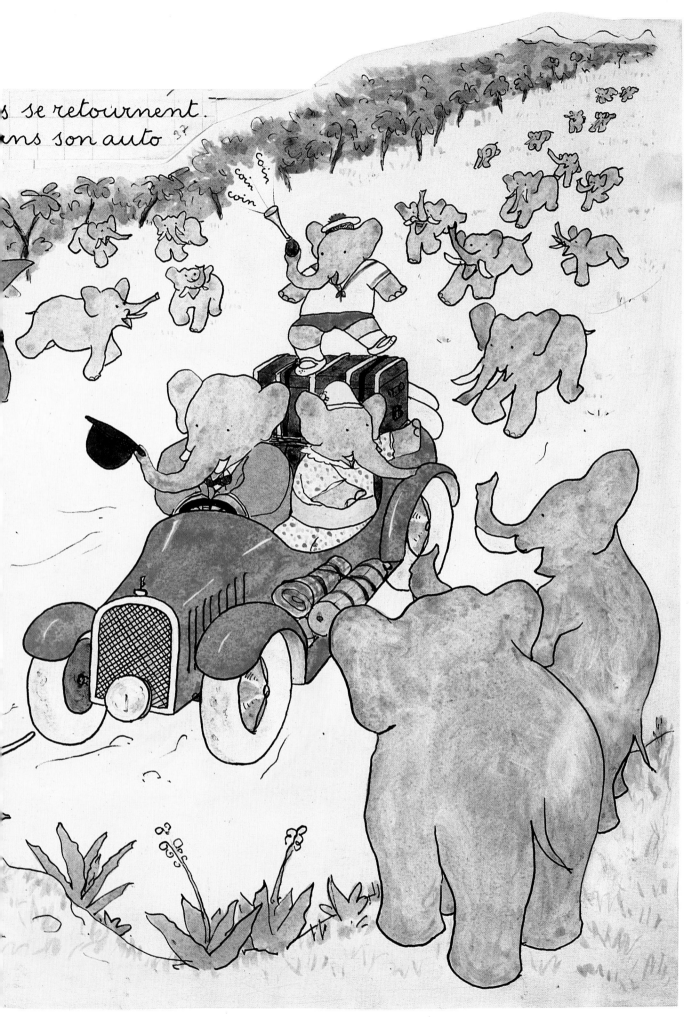

THE STORY OF BABAR (1931)
Babar's Return to the Forest
Ink and watercolor, 36 × 53 cm (14 × 20¾″)

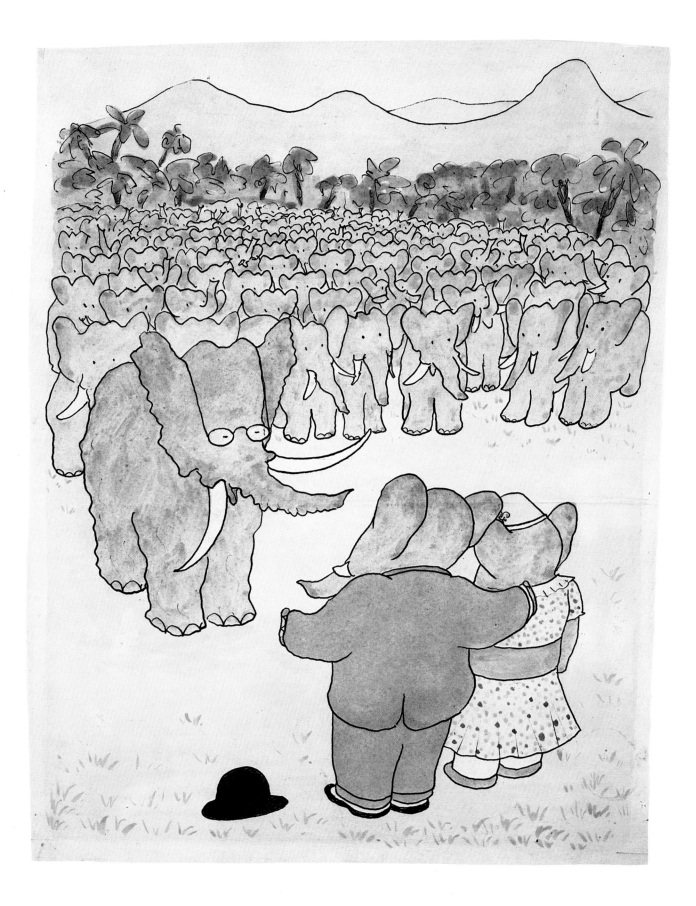

THE STORY OF BABAR (1931)
"Long live Queen Celeste! Long live King Babar!"
Ink and watercolor, 32 × 25 cm (12½ × 10″)

that is almost irresistible—for adults as well as children—to squeeze. The "B" on Babar's steamer trunk calls attention to the pleasure of personalized objects. De Brunhoff's full curves give great warmth and harmony to that linking of the rough and tutored sides of life. Precisely because de Brunhoff has drawn it with an irregular, almost childish line, we trust what we are seeing. The form of Babar's urbanity makes it somehow pure, while in other hands it could be jaded. This picture of Babar tipping his hat was so successful that de Brunhoff also used it for the title page of the book.

Following his return, Babar promptly announces his engagement to Celeste. She is perfect for his wife since she too stands on two feet, dresses well, and has dined in Paris. What distinguishes Babar and Celeste is not only that they have been exposed to human ways, but they have mastered them. In the Babar books that acquisition of knowledge and ability is the equivalent of the maturation process human children undergo as they turn into adults.[27] There is some regret at abandoning the natural, untutored state in which we all start out, but the acquisition of worldliness offers its rewards. De Brunhoff celebrates that progress from helplessness to civilization in an illustration in which his own graphic clarity and order parallel Babar's new control and skills.

Jean de Brunhoff was suggesting a code of behavior that reflected the time and place in which he lived. The notion that the taming of wildness would guarantee a degree of safety and happiness, whether for young French children or jungle creatures, was in the air. The Exposition Coloniale of 1931 gave it great voice. (The de Brunhoffs visited it in an outing that figured significantly in family lore because Mathieu was briefly lost at the part of the exposition situated at the zoo in Vincennes, a trauma that for many years Laurent believed had happened to *him*.) Controlled exoticism was a national passion. This took form in the governing of distant lands as outposts of France, the captivity of fabulous beasts in the Paris zoos, and the display of primitive art in the secure vitrines of the Musée de l'Homme.

Like England's Prince Charles and Princess Diana, Babar and Celeste are the sort of monarchs who win the hearts of all but the most ardent antiroyalists. Their distinction comes in part from how they dress and comport themselves, and in part from their having a few rough edges beyond the perfect demeanor. Like the fairy-tale princes and princesses that rivet the attention of even the poorest children, the royal elephants temper extraordinary trappings with ordinary decency. The contrast between civilization and savagery here and in the other books has been interpreted by some readers as colonialist propaganda, extolling privilege and a hierarchical system.[28] But in fact what makes Celeste and Babar such a winning pair has nothing to do with class distinction—they come from exactly the same background as everybody else—but rather with their competence and concern for others. That scene with hundreds of elephants gaga over the worldly pair before them calls to mind pictures of Jackie Kennedy in French clothes and a pillbox hat, especially when Jack has his arm around her; these pairs are as affable as they are elegant.

The horde of naked elephants—the type that stand on all four feet—ecstatically bob their big floppy ears under equally ecstatic-looking palm trees as they gaze at their upright, humanly clad sovereigns. The fiancés, seen from behind, are linked by soft loops; Babar's right arm (foreleg) flows firmly into Celeste's lacy collar. The crowd is also a series of loops, their ears taking the form of gentle waves so that en masse they resemble a calm sea. The profile of the distant mountains swings along smoothly.

THE STORY OF BABAR (1931)
"King Babar and Queen Celeste are indeed very happy."
from the printed book

The composition juxtaposes density with breathing space. Parts of the painting are packed, while the foreground and sky offer a void that isolates key details. Cornelius's spectacles bespeak age and wisdom. As before, Babar's bowler symbolizes worldliness and his experiences with humankind. But if earlier he sported it in his trunk with great bravura, here it is placed on the ground, suggesting humility and proportion. In the original watercolor the bowler reads as a far darker black than in the printed books, so it seems even more important—both symbolically and as a visual foil to all of the lighter hues.

Babar and Celeste have a splendid wedding. They get beautiful clothing for it, and have a marvelous party. The elegantly outfitted bridal pair appear to be having the time of their lives. The decorations are super. There's great dancing, with music provided by a classy band of monkeys. The guests behave impeccably. This is the fitting finale to the fantasy that you can go from abject suffering to receiving all the material goods the world has to offer, and—just because you behave like a perfect prince by doing your lessons, charming your dinner guests, and being both elegant and down-to-earth—return to your homeland to rule it with a beautiful spouse at your side. Naturally, these splendid events take place in the most appealing settings. The ceremonies are august, the festivities sparkling.

Finally, the frivolity—fun while it lasted—ends. In a lovely transition, de Brunhoff shifts the mood

THE STORY OF BABAR (1931)
"Now the world is asleep."
from the printed book

completely. Two facing pages show evocative black-and-white scenes of a starlit night. On the left, Babar and Celeste, seen from behind, look at the radiant evening. Happy as they were to dance with friends, there is nothing they enjoy more than their shared solitude. On the right is the scene alone, with a text that opens, "Now the world is asleep." As amusing as all the dressing and dining and partying have been, what lasts above all is nature. The sketchy palms, fluid mountains, and white pinprick stars are unbeatable. This closing image is at once light-hearted and profound.

The "Au Revoir" on the following page takes those words literally; the text suggests that we'll see Babar and Celeste on "further adventures." Jean de Brunhoff knew from the start that he had the makings for more than this single tale. Given the quality of the art and the charm of the story—and the easy tone and rich complexity of both—his earliest readers must have been relieved. *The Story of Babar* provided a fertile foundation upon which Jean de Brunhoff could build for the rest of his life and that gave Laurent de Brunhoff a fine starting point for further books in a manner very much his own.[29]

Jean de Brunhoff had filled a spiral-bound school notebook with the watercolors and classic French schoolchild's cursive script that told the tale of the elephant. It didn't take long for Lucien Vogel and Michel de Brunhoff to persuade him that the notebook merited a larger audience than just the family.

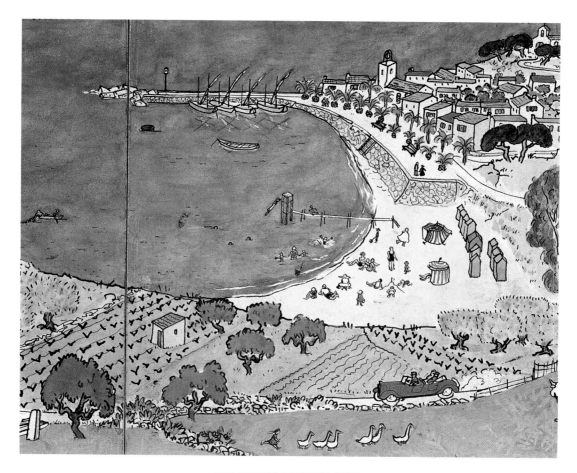

THE TRAVELS OF BABAR (1932)
The Balloon Ride (detail)
Ink and watercolor, 12 × 15 cm (4¾ × 6″)

Their firm, Editions du Jardin des Modes, brought out *L'Histoire de Babar* in 1931, the year after it was written. They reproduced the art and handwritten script exactly as they were in de Brunhoff's notebook, in a large format book 10¾ inches wide, 14½ inches high. In the realm of children's books, it is elephantine. Sheer size makes it and its sequels (all of Jean de Brunhoff's books and many of Laurent's were printed with the same generous dimensions) comforting and totally absorbing. The books feel like special objects. To children, they are unusual toys; to adults, fine-art portfolios.

Owned by Condé Nast, Jardin des Modes had never before published a book that wasn't about fashion. It could be claimed, of course, that *The Story of Babar* was more profoundly related to the subject of fashion than an album on a single style or designer, but Condé Nast probably did not see it that way. In any event, *Babar* was such an instantaneous success that they immediately published a second edition. In 1935 Jardin des Modes sold the Babar books to the large publishing company Hachette, which has been the French publisher of *The Story of Babar* and its sequels ever since.

In the early 1930s, an American, Robert Haas, head of the publishing firm Harrison & Smith, came across a copy of *L'Histoire de Babar* in Paris. Enchanted, he arranged to publish the book in America, with his wife Merle Haas as the translator. It came out in 1933. A few years later, Harrison & Smith merged with Random House, then headed by Bennett Cerf, and thus began a connection that has been

maintained ever since. A British edition also came out in 1933, published by Methuen, with a preface by A. A. Milne. Today the book has been translated into eighteen languages.

In 1932 Jardin des Modes brought out *The Travels of Babar*. As with *The Story of Babar*, *Travels* was directly reproduced in full size from Jean de Brunhoff's hand-written text and watercolors. The language accompanying the first two-page spread is simple enough: "There was the ocean, the big blue ocean." But the painting of that ocean and of the surrounding landscape is an astounding illustration of earthly beauty. De Brunhoff's art in general is unequivocal. There is no contradictory information. Dapper epitomizes dapper; the jungle is as thick and noisy as possible. Praise is glorious while scoldings are mortifying. Happy days are halcyon, but dangers are unquestionably real. And in this first large image from *The Travels of Babar*, not only is the air "balmy" and the wind "gentle," but every apple tree and milkmaid, cabana and sailboat evoke well-being. The clarity that gives this painting, and the Babar books in general, their hold on children, can grip observers of any age. Mature readers, too, are happily transported to Mediterranean lushness and perfect summery climates. We are in the gondola of that balloon, coming upon the lively harbor and the rich blues of sea and sky as if for the first time.

In the actual watercolor, the rough brushwork in the sea and sky announces clearly that a painter has been at work here. The stonework along the beach similarly reveals the gifted human hand. We picture de Brunhoff sitting in his studio in Chessy on a perfect summer day, using a fine-pointed pen to achieve the thick and thin outlines of the stones. Despite the appearance of spontaneity, he has placed the squiggles with utmost care.

Other details of this painting locate de Brunhoff once again in the tradition of Jan van Eyck, in his power of observation and ability to paint on a minute scale. Consider, for example, the tiny bathers. Minuscule as they are, they take the poses and attitudes of universal types: the splasher, the nimble stroker, and the diver; those who tread water so that only their heads show; and the mother and children holding hands and trying to decide how far in to go (remarkably like Cécile de Brunhoff and her sons as they appear in a photograph from that time). The group on the beach includes a small girl with a bucket, children building a sand castle, a fat woman sitting on a folding stool and wearing a straw hat, and an intense reader. This warm, shrewd portrayal of seaside leisure—of which these details are just a few—is all contained within an area of the actual painting smaller than three inches by three inches. Numerous other vignettes are not far away: the beautifully articulated figure of the farm woman milking a cow, the spiffy pair in their chauffeur-driven touring car, the shepherd with his flock and eager dog. And there is the picturesque village with its red-tile roofs playing off one another at charged angles.

The Travels of Babar and Jean de Brunhoff's subsequent books follow the pattern established by the original *Story of Babar*. Disaster strikes hard on the heels of bliss. Babar again falls victim to fate, this time at the hands of nature rather than man with a shotgun. His balloon is blown away in a storm. Then fate quickly offers a solution; Babar and Celeste land on an island.

This haven, however, is menaced by ferocious cannibals. Their depiction is an unfortunate example of the sort of prejudice that marked the French attitude toward the inhabitants of its colonies in the 1930s. They are fat-lipped, bug-eyed stereotypes. Troublesome as de Brunhoff's imagery is here, it was

consistent with the popular art of the times. Jean de Brunhoff was forever turning to the world around him for his subject matter—popular amusement alongside the Marne, the style of hats the Old Lady wore—and in the 1930s certain vestiges of colonialism were simply part of everyday living for the French bourgeoisie. According to Laurent de Brunhoff, the wild characters in *Travels* look just like the wide-mouthed, white-toothed, big-hipped black man in a popular poster of the day saying "Y'a Bon Banania." The ungrammatical "Y'a Bon" suggests that not only did the natives look wild, but they couldn't handle the language properly.

Laurent de Brunhoff does not minimize the evils of this imagery. He assiduously avoids such stereotypes today. When *Travels* was reprinted in 1981 in *Babar's Anniversary Album* and he had to abridge it, he edited these cannibals out. In the 1960s, when Toni Morrison was an editor at Random House, she protested similar stereotypes in Laurent's own *Babar's Picnic* of 1949; Laurent, embarrassed to discover that he had unconsciously used a cliché of the prewar period, was happy to see the book dropped and never reprinted. He now readily sees the flaws in this aspect of the Babar vocabulary that he learned from his father—as intrinsic to French culture of that era as the image of Tonto the wild Indian was when the Lone Ranger was in his heyday in America.

Whatever the reasons behind the depiction of those cannibals who inhabit the island where Babar and Celeste have landed in *Travels*, it is a relief to see them rescued from it. Fortunately, an amiable whale comes to aid the honeymooners. She gives them a bareback ride that is the subject of one of de Brunhoff's loveliest illustrations, showing two of nature's largest species working in unison. The whereabouts of the original watercolor are unknown today, but the printed image in the large-format edition of the book is good and is reproduced in the catalogue.

Danger quickly reemerges in the form of highly civilized Europeans rather than island savages. Having in *Story* gained their crowns through their association with such people, in *Travels* Babar and Celeste lose status because of them. A big beautiful ocean liner appears to save the elephants, but in fact its captain imprisons the unhappy animals and turns them over to the circus. Their fortunes soon change for the better, though. The circus goes to the town where the Old Lady lives, and before we know it the elephants and the Old Lady are in the back of a splendid touring car on their way to an Alpine ski resort. Again Jean de Brunhoff based one of his illustrations on his family's enchanted existence. The original watercolor of the spectacular two-page spread of Babar, Celeste, and the Old Lady skiing in view of the Hôtel Suisse was among a group sold in 1938 (and for which there is no information about its current location); the image remains one of the masterpieces of the actual books, as well as of posters and calendars.

In *Travels* de Brunhoff has some fine angles on the human—and elephant—comedy. Some are pure invention, like the idea of Babar using his trunk to puff air into a fire. Others are above all illustrations of the charming tale, like the painting of Babar and Celeste in a lifeboat approaching the majestic ocean liner. But sometimes Jean de Brunhoff's flair isn't so much for imaginary occurrences as for familiar subjects like the sight of people walking down the gangplank of a ship. The work has a texture and richness rare in illustrated books, thanks to the same sort of crosshatching that was used in the admirable scene of Babar at the photographer's in *Story*. De Brunhoff's original watercolor bears his instructions to the printer to use both gray and black ink. The result is a background that dramatically

THE TRAVELS OF BABAR (1932)
"A lifeboat rescued Babar and Celeste."
Ink and watercolor, 30 × 24 cm (11¾ × 9½")

THE TRAVELS OF BABAR (1932)
The Gangplank
Ink and watercolor, 16 × 20 cm (6¼ × 8″)

accentuates one of his finest fashion parades. Its participants, while of an era, are timeless stock characters. De Brunhoff mastered the way people use clothing to establish their identities and the ability of body type and posture to denote character.

We recognize the different personalities here. The burly man in front, his head thrust forward and his pipe clenched in place, with his British-style plaid coat and cap and yellow muffler (undoubtedly Scottish cashmere), is confident, taciturn, a bit of a dinosaur. The gray lady (even her gloves are mole-colored) with set jaw and spectacles is prim and forbidding. The fellow in a broad-brimmed hat and blue suit (it's the color worn by middle-echelon bankers or detectives) could hardly be more earnest, or serious about his business. The pinch-waisted woman in green, with her finely curled platinum hair and excess of rouge and eyebrow pencil, is the floozy of the group. In her fur collar and muff—probably chinchilla—she is either a movie star or someone who fancies herself one. As for the white-bearded man who resembles both Freud and Matisse, he is a bit dour, but unquestionably a person of considerable achievement. His fine eyeglasses, matching topcoat and bowler, and above all his bearing, make him the most dignified and thoughtful one of the lot. This gentleman appears all the more in command of himself because of the contrast offered by the goofy and uncertain pair who follow him. In a half-page illustration, de Brunhoff has presented a varied and intriguing cast of characters.

The two-page illustration of *Fernando's Circus* copes with the complex task of encompassing the action in both the ring and the bleachers. De Brunhoff's vantage point helps make this possible. He seems to have approached this scene, like so many others, from the perspective of a low-flying bird. The viewing angle helps account for the feeling in these books that we are, quite literally, on top of things: not dominating, but modestly in command.

Like many other major late-nineteenth and early-twentieth-century artists, de Brunhoff was preoccupied with the world of entertainment. If the Marne scene in *The Story of Babar* recalled Seurat's *Grande Jatte*, *Fernando's Circus* in *Travels* calls to mind the same artist's *Le Cirque*. All of these works present human techniques for diversion. What de Brunhoff makes clear in this illustration is that one creature's amusement is another's agony. In the story, de Brunhoff presents the circus from the animals' point of view. In the art, he does what Picasso does with bullfights, by simultaneously touching on both the splendors and horrors of human amusement.

Such originality is the essence of the art in Babar. In the crucial battle scene toward the end of this book, the image of the elephants' camouflaged backsides is another example. The ample rears are painted with eyes and topped with false hair. This witty idea is serious commentary on the nature of appearances. It addresses some of the same concerns as Surrealism. The transformation of images has the quality of subconscious thought. The visual deceptiveness makes us consider what our expectations of reality are. De Brunhoff's novel vision not only amuses children; it also sparks the imagination of viewers of all ages.

THE TRAVELS OF BABAR (1932)
The Elephants' Camp
Ink and watercolor, 20 × 15.5 cm (10 × 8″)

THE TRAVELS OF BABAR (1932)
Fernando's Circus
Ink and watercolor, 34.5 × 53 cm (13½ × 21″)

For *Babar the King* of 1933, the publisher had Jean de Brunhoff change his working method. First de Brunhoff gave the printers black-line drawings from which they made proofs. Then he hand-colored those proofs. He continued to use this technique in his subsequent books, although for the last two his publisher and Laurent de Brunhoff provided the colors after the artist's death.

In spite of the variation in method, *Babar the King* is entirely consistent with the preceding two volumes and has a similar plot. Different details, however, present fine new possibilities for illustrations. Babar develops the city of Celesteville. Celesteville itself has identical huts and a Bureau of Industry that extol the possibilities of a highly regimented, feudal-like system with overtones of socialism.[30] Happy workers in identical houses thrive under the strong leadership of a single benevolent leader: Babar. De Brunhoff, a supporter of the socialism advocated by the Front Populaire,

BABAR THE KING (1933)

Celesteville

Pen and ink, 26 × 52 cm (10¼ × 20½″)

Overleaf:

BABAR THE KING (1933)

Babar's Dream

Watercolor on black-line proof, 36 × 53 cm (14¼ × 21″)

.......de gracieux éléphants ailés
qui chassent le Malheur
loin de Célesteville,
et ramènent avec eux
le Bonheur.—
A ce moment, il se réveille,
et se sent mieux.

BONTÉ

PEUR

DÉSESPOIR

MOLLESSE

MALHEUR

MALADIE

COLÈRE

BÊTISE

DÉCOURAGEMENT

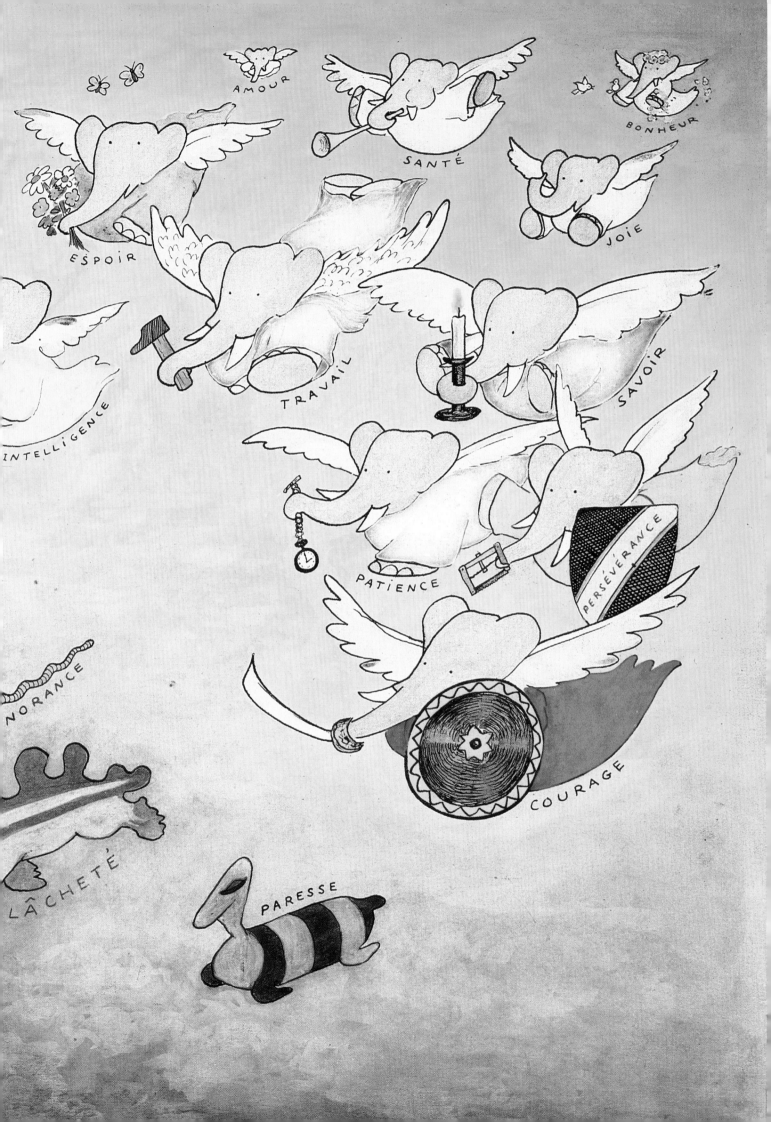

BABAR THE KING (1933)

In the Park

Watercolor on black-line proof, 29 × 51 cm (11½ × 20″)

BABAR THE KING (1933)

The Parade

Watercolor on black-line proof, 31 × 53 cm (12 × 21″)

belonged to that part of the intelligentsia of the era that idealized the concept of the greatest good for the greatest number of people, although he was less political than most of his leftist family.

In any event, even though the buildings in Celesteville may resemble enlightened middle-class public housing of the 1930s, few inhabitants of those model communities were ever able to indulge the penchant for dressing well evident in the inhabitants of the elephant city. If there are the requisite "sturdy clothes for workdays," there are also "rich beautiful clothes for holidays" so stylish that they make the elephants dance "with glee." They sport perfect tennis whites, useful day clothes, and magnificent fancy-dress wear. The book came out at a time when many readers could afford very little garb of this sort, but must have loved to fantasize about the possibilities. Like some American movies of the Depression, de Brunhoff's illustrations enabled many viewers to indulge in high-style living in the only form available to them.

In Celesteville, the elephants enjoy, more than ever before, the attributes of "civilization": fine clothes, tasty desserts, sophisticated schooling, tennis, a marvelous theater. The two-page spreads of the city have that symmetry that de Brunhoff reserves for grand occasions. Lots of people out in their finery are joining in celebration, and the visual balance and precise organization of myriad elements impart a formal structure to their festivities. The strong affinity Jean de Brunhoff had in his student days for the work of Raoul Dufy is evident in these illustrations. Dufy was a great observer of modern life: its entertainments, its fashions and trappings. Moreover, he was an artist of great taste and light touch. Particularly in watercolor, Dufy knew how to breathe air into his compositions, to activate them and maintain their rhythm. He could articulate big spaces while capturing the nuances that define a scene.

The requisite crises occur in *Babar the King* when the Old Lady is bitten by a snake and then when Cornelius, the oldest elephant, is half-suffocated and injured when his house burns. (Tellingly, the fire is his own fault. It started when Cornelius mistakenly threw a lit match into a wastebasket rather than an ashtray. The Babar books are always in part a father's means of instructing his children on the practical as well as the moral sides of living.) These two near-tragedies pave the way for one of the de Brunhoff's greatest images, *Babar's Dream*. This scene of demons and elephantine angels has the drama of a *Last Judgment.* Except that while those paintings make both heaven and hell seem like equally feasible possibilities for the afterlife, *Babar's Dream* has good drive out evil.

I know of one young father who claims that at a point when he was in despair because of problems in starting a new business, looking at *Babar's Dream* with his four-year-old restored him. Therapy, sports, and several forms of meditation had failed where this illustration succeeded. Such is the power of de Brunhoff's image of "intelligence, goodness, hope, work, patience, courage, learning" and of the names and faces he gives to the evils of "fear, laziness, ignorance." Set against murky darks and resonant lights that are emotionally evocative, each figure is a spectacular feat of invention. The human rider on a green, horned, four-legged beast is a particularly frightful evocation of "misfortune." As for the creatures that represent forms of anxiety rather than bad luck or the vagaries of life, they are so obviously abhorrent that seeing them here we vow never to let them get us again. By recognizing what a pathetic devil "despair" is—with its wily face and infantile pajamas—we learn to avoid its grip. With his electric-shock hair, green skin, and bat's wings, "fear" is so horrid and ridiculous that no

THE ABC OF BABAR (1934)

E

Watercolor on black-line proof, 21 × 33 cm (8¼ × 13″)

THE ABC OF BABAR (1934)

N

Watercolor on black-line proof, 20 × 33 cm (8 × 13″)

THE ABC OF BABAR (1934)
P
Watercolor on black-line proof, 20 × 31 cm (8 × 12″)

THE ABC OF BABAR (1934)
T
Watercolor on black-line proof, 20 × 33 cm (8 × 13″)

intelligent person should ever succumb to it. Seeing "laziness" and "discouragement" with their beanbag bodies and inept legs, our instinct is to eradicate them from our lives once and for all. De Brunhoff manages to summarize emotions with the same humor and bite with which he evoked the characters walking down the gangplank in *The Travels of Babar*. These images succeed both as individual creations and as universal types. However, while evil has many faces, goodness is less interesting; the elephants that represent assorted virtues all look pretty much the same.

The book that Jean de Brunhoff produced the following year was an illustrated alphabet. Each page of *The ABC of Babar* presents numerous examples of words starting with the letter in question. Because of their different function, these alphabet pages tend to be less fluid than the illustrations of the previous three books, but they are packed with enticing details. They present experiences in which it would be a pleasure to participate. *T* offers urban bliss. A delicious-looking *t*ea with an irresistible raspberry *t*arte is served in the isolated comfort of a pleasant *t*errace as *t*raffic struggles below. (The French words also start with *t*s.) The well-articulated parapet of the terrace gives its inhabitants a desirable edge of security. Up above the tumult of the city, they enjoy a slight remove from the inconveniences of life. Their distance, almost royal, helps give them—and vicariously us—tremendous

ease. Ordinary people (note the species) struggle away in confusion below as a streetcar is held up by a *t*axi whose driver has ignored a detour sign necessary because of some pipes being laid. But the elephants on their nice apartment terrace have nothing more to worry about than whether one of them might drip some of the delicious dessert on his charmingly hideous tropical print shirt.

Jean de Brunhoff's next book, which came out two years later, in 1936, was devoted primarily to Laurent's and Mathieu's favorite character in the entire series, the monkey Zephir. (Although called *Babar and Zephir* in English—presumably to make sure that readers knew the series to which it belonged—it is *Les Vacances de Zephir* in French.) It is one of Jean's most lyrical works, a great favorite of Laurent's to this day. Starting with the opening page, the adorable monkey is an exceptionally likable character, ecstatic to be returning on vacation to his family, yet full of "ennui" to be leaving his beloved elephant friends and the Old Lady. But, as in *The Travels of Babar,* it is the first two-page spread that really hooks us. This is the village of the monkeys, where the reunion of Zephir and his mother occurs at the train station in the distant background. Each monkey house is an inventive, enticing architectural folly. The "Restaurant des Singes" is in the tradition of Renoir's *The Luncheon of the Boating Party* and Monet's *La Grenouillère,* an isolated restaurant on a small island—given that a tree house is an island of sorts—at which the French talent for plein air dining peaks.

BABAR AND ZEPHIR (1936)
Zephir Leaving on Vacation
Pen and ink, 9.5 × 17 cm (3¾ × 6¾″)

Zéphir arrive à la gare de la ville des singes
et se jette dans les bras de sa maman.

« Comme tu as grandi, mon chéri! »
lui dit-elle en l'embrassant.

BABAR AND ZEPHIR (1936)

"Zephir arrives at the station of the village of the monkeys."

Watercolor on black-line proof, 30 × 52 cm (12 × 20½")

BABAR AND ZEPHIR (1936)
Zephir Talking with the Nightingale
Watercolor on black-line proof, 21 × 23 cm (8¼ × 9″)

De Brunhoff generally makes us ravenous at least once per book. In *Zephir* this begins at the Restaurant des Singes and continues when Zephir's mother prepares a chocolate banana soup when he returns home to their cozy hut. While she cooks, he plays "cache-cache"; if the soup was imaginary, there is no doubt where de Brunhoff got his idea for the game, and why Laurent and Mathieu must have felt so strongly that Zephir was one of them.

After settling into his inviting bed, Zephir is wakened by a nightingale. In the watercolor of this subject, Jean de Brunhoff again evokes the pregnant stillness of the closing scenes of *The Story of Babar,* only here he adds evocative moonlit colors rather than leaving the nighttime black and white. The nightingale informs Zephir that Babar has sent him a gift. It is a boat, a vehicle that will lead to some splendid scenes, like one of Zephir fishing and catching a mermaid. This sea goddess implores the monkey to release her; kind fellow that he is, he does so, but his generosity leaves him lonely. Seen from the back in his rowboat, his arms at his sides and the oars hanging limp in their locks, Zephir makes a poignant vision of pensiveness and solitude at sea.

Zephir next takes a typically adventurous course. The Princess Isabelle — daughter of General Huc,

BABAR AND ZEPHIR (1936)
Zephir Fishing a Mermaid
Watercolor on black-line proof, 31 × 24 cm (12 × 9½″)

BABAR AND ZEPHIR (1936)
The Monsters Fall Asleep
Pen and ink, 20 × 22 cm (8 × 8½″)

BABAR AND ZEPHIR (1936)
Zephir at Sea
Watercolor on black-line proof, 16.5 × 23 cm (6½ × 9″)

president of the Monkey Republic—is missing. She was whisked off in a green cloud, and the monkey army must save her. Colonel Aristobald promises to do his best, and gives General Huc a rather fascist-looking salute. That hand gesture sums up the foibles of military fanfare, a recurring theme in these books. The soldiers, in fact, fail at their mission; it takes the untrained, easygoing Zephir to rescue Isabelle. He calls on the mermaid whom he released, and she leads him to a wild island to obtain the counsel of her aunt Crustadele. They travel there on a fish-drawn seashell that is among the most spectacular of de Brunhoff's imaginary vehicles.

Crustadele is a remarkable creature. On her black rock throne in a deep grotto, she is a deity to contend with. Laurent and Mathieu actually had some say about this illustration of her. Their father showed them two versions of the scene, one with the sky white rather than blue, the other as the image finally appeared, and gave them their choice. (See page 172 in the catalogue for the unused version.) The question may have been loaded, meant above all to demonstrate the effect of color on mood and spatial movement. But not only did it nurture visual connoisseurship. It also allowed the boys to feel in charge.

Crustadele indeed knows Isabelle's whereabouts. Zephir follows her counsel and finds the princess. She is surrounded by extraordinary creatures (called "monsters," they actually look quite amiable) in a splendidly imaginative rocky landscape. Zephir charms the alleged beasts by dressing as a clown, playing the violin, and regaling them with stories until they dance themselves to sleep, which enables him to take Isabelle away. The message is clear: ingenuity, tenacity, and charm have it all over military

BABAR AND ZEPHIR (1936)
"Eleanor guides them toward a wild island."
Watercolor on black-line proof, 19 × 24 cm (7½ × 9½″)

tactics. General Huc is properly impressed, and congratulates Zephir and Isabelle with a great gesture of appreciation. The general and his troops are locked into stiff military stances, and Zephir and Isabelle comport themselves like good little soldiers, but the carefree dancing on the page that follows is a tribute to what ultimately triumphs.

At about the same time that he was working on *Zephir,* Jean de Brunhoff designed wooden reliefs to decorate the French ocean liner *Normandie.* Work was being done on the interior of the ship between its launching in 1932 and its maiden voyage in 1935. It had a first-class dining room longer than the Hall of Mirrors in Versailles and almost as glassy. For the children of those passengers who dined with their own elegant images reflected on all sides there was a special dining room covered with "trunk-to-tail chains of Babars."[31] When the *Normandie* docked in New York for the first time, one of the tugboats that warped her to her mooring towed a helium-filled Mickey Mouse, at which moment the elephant who was the mascot of France met the mouse who was the mascot of the United States. The *Normandie* burned in the Hudson River in 1942, and there are no extant photos of de Brunhoff's reliefs, but some drawings for those reliefs remain. Used to indicate outlines of the Babars to be cut out of plywood,

BABAR AND ZEPHIR (1936)
Crustadele, Zephir, and Eleanor
Watercolor on black-line proof, 28 × 23 cm (11 × 9″)

BABAR AND ZEPHIR (1936)

Zephir Looking at the Monsters

Watercolor on black-line proof, 30 × 54 cm (12 × 21½")

which were then painted in varying shades of gray, they are more stylized than most of Jean de Brunhoff's work. The forms have an abstract quality not unlike the shapes in the reliefs of Jean Arp. De Brunhoff responded well to the demands of this commission, particularly with details such as an elephant's trunk wrapped around a rope, both witty and legible in the new medium.

Jean de Brunhoff wrote *Babar and His Children* in 1936, inspired by the birth of his third son, Thierry. Perhaps to mitigate the sibling rivalry that Laurent and Mathieu might feel upon the birth of their brother, he gave Babar and Celeste triplets, thereby establishing the idea of three children of equal importance to their parents. So Pom, Flora, and Alexander joined the series.

Because of his own new baby, de Brunhoff must have had most of his subject matter very handy. But if the rattles, cradle, and crib were there before his eyes, he still managed some unique touches, like a rope swing hung from two elephant tusks. The plot moves between the plausible—the babies' pram rolls downhill—to the purely imaginary; when Alexander is thrown over a precipice, he is rescued by squirrels and a giraffe. Alexander floats down a river in a hat and meets up with a crocodile but is saved by his father. It's the usual Babar chain of events, but somehow the plot is a bit tired here and the illustrations less winning than in the earlier books. Jean de Brunhoff may well have been feeling the effects of his ill health when he worked on it.[32]

BABAR AND ZEPHIR (1936)
The Salute
Pen and ink, 18 × 17 cm (7 × 6¾″)

Babar and His Children was initially commissioned as a serial with black-and-white illustrations for the *Daily Sketch,* a London newspaper. It was not published as a book until 1938, the year after Jean de Brunhoff died. The task of coloring the line proofs, therefore, fell upon the publisher. Michel de Brunhoff, as artistic consultant to Hachette, asked thirteen-year-old Laurent to do two of them. It was a natural enough request; he was highly familiar with the process of making this sort of illustration. When he was in good health, Jean would show Laurent and Mathieu his latest pictures for the Babar books every afternoon about four o'clock. He would give the boys little jobs, like advising what color coats people should wear. He also heeded their suggestions, adding Zephir after they saw the scene of Cornelius conducting the singing elephants in *Babar the King* and asked where the little monkey was. By the time he was ten years old, Laurent regularly sketched elephants. So he was ready to go.

One of the illustrations he colored was the nursery scene; the other showed Alexander stuck in a tree. Laurent patterned the nursery curtains with a bold orange-and-yellow plaid. He found colors that were both brighter and more subtly related than those used by the professionals at Hachette. Rather than merely filling in the lines, he used his brush with remarkable freedom and dexterity. For the outdoor scene he knew precisely where to use the dark greens in front of the light. He performed the assigned task respectfully but not meekly. Laurent knew the boundaries—literally and figuratively—but was not hemmed in by them. He never would be.

BABAR AND ZEPHIR (1936)
General Huc Congratulating Zephir and Isabelle
Pen and ink, 13 × 17 cm (5 × 6¾″)

BABAR AND HIS CHILDREN (1938)

The Nursery

Watercolor on black-line proof, 31 × 59 cm (12¼ × 23¼″)

(Color by Laurent de Brunhoff)

Jean de Brunhoff's last book, *Babar and Father Christmas,* was another black-and-white commission for the *Daily Sketch.* Confined to a monochromatic spectrum, de Brunhoff nevertheless achieved rich tonality in his illustrations for the tale. But when Hachette published the book in 1941, they asked Laurent, then age sixteen, to add color to the cover of the book and had their staff provide it for the rest of the illustrations. *Father Christmas* lacks the visual strength of books like *Travels* and *Zephir,* but it remains an engrossing story. In the first few pages expectation, determination, sadness, tenacity, and fantasy all follow one another in rapid succession. First Zephir tells Arthur, Babar, and the recently born elephant triplets about Father Christmas. They write to him, but he doesn't answer. Babar therefore decides to go see the great man. That journey allows one of the major sartorial moments of the entire series, when Babar selects a jazzy window-pane-check coat with a dashing cape as his travel attire. It gives him even more aplomb than usual, especially compared to the miserable-looking human porter who carries his bags. Babar is both dashing and humbled; at the same time that he sports the cape that

BABAR AND HIS CHILDREN (1938)
Alexander in the Tree
Watercolor on black-line proof, 41 × 52.5 cm (16¼ × 21¾")
(Color by Laurent de Brunhoff)

links him to hundreds of other Bond Street shoppers, he deliberately gives up his crown. He may always wear his symbol of kingship in the jungle, but he has opted to seek Father Christmas incognito.

Father Christmas, appropriately, lives in Europe. Where else could great gifts come from? Once there, Babar experiences a series of ups and downs. Good luck (three mice at Babar's hotel who know where Father Christmas is) leads to disappointment (he is merely a tree ornament), which is quickly supplanted by optimism (some birds will show Babar the real Father Christmas) followed by failure (he is simply an old man who poses for painters). As always, tenacity is essential. Babar is like one of those British army officers whose gospel is, "Order! Disorder! Counterorder!"

Ever diligent and inventive, he finds a book about Father Christmas, and when it's in a language he doesn't understand, he locates a translator. Never mind that the first translator can't do it; he finds another. And although he is exasperated upon learning that Father Christmas lives in an obscure town with an archaic name, he still persists, this time abetted by a bit of chance in the form of a small dog who will be able to lead him to Father Christmas's workshop, if only he can have a doll that was made there. He needs it to trace the scent. The doll is owned by a little girl, so the ingenious—one might say crafty—Babar buys her a new doll so that she will give up the one from Father Christmas. He then feeds sugar to the dog, and off they go.

Duly rewarded for undertaking the difficult Nordic journey, Babar encounters the gnomes who are Santa's helpers. De Brunhoff is, after all, a moralist, and one of his favorite messages is that there are always rewards for those who surmount obstacles. Babar gets stuck in a ferocious blizzard, but finds a solution by building a primitive sort of igloo. Soon enough, he ends up at Father Christmas's and gets an alcohol rub and a cordial. He changes into a dressing gown and savors a good soup. (Father Christmas ladles it out of a tureen that was probably an everyday object at Chessy.) Babar has earned these rewards, not just for his courage, but also for his generosity. The point of his trip after all is to arrange for baby elephants to receive presents just like the ones that human children get.

Next comes a note of realism: Father Christmas laments to Babar that he is so tired he was hardly able to take care of humans the previous holiday season. His fatigue may well be a reflection of Jean de Brunhoff's own deteriorating condition at the time. The elephant's response to this is a model of gallantry and thoughtfulness. He offers the old man a trip to his warm and sunny homeland. Father Christmas accepts the invitation, and marvelous illustrations result: Father Christmas riding a zebra and reclining in a hammock. The book offers a lot of desirable stopping points. First there was picturesque ski country; then the luxury resort with thick towels, massages, and fine cuisine; and now the tropics.

When Father Christmas is resting in Celesteville, Babar's children are warned not to disturb him. This sort of touch gives authenticity to de Brunhoff's books. Young readers can more easily believe in the fantasy because they can recognize the strictures and identify with the baby elephants on whom they are imposed. The realism makes more credible the ensuing magic of Father Christmas zooming off in a Santa-like manner and later returning with a Christmas tree.

The concomitant euphoria is followed by the sort of bittersweet realism with which these books often close. Father Christmas has to leave. But there will, of course, be a future; he promises to come back. In fact, the real benefactor in this book—Jean de Brunhoff himself—would never return again.

BABAR AND FATHER CHRISTMAS (1941)
Babar in the Storm (as illustrated in *Daily Sketch* 1937)
Black wash, gouache, and ink, 18 × 27 cm (7 × 10½″)

BABAR AND FATHER CHRISTMAS (1941)
Babar Digging His Shelter in the Storm (as illustrated in *Daily Sketch* 1937)
Black wash, gouache, and ink, 18 × 27 cm (7 × 10½″)

The last time that Laurent de Brunhoff saw his father, Jean de Brunhoff was lying on his back in a hospital bed, forced to remain very still. The memories are vague and faltering, the cloudy impressions of a twelve-year-old confronted, if unconsciously, with the imminent death of an adored parent. This was the end of that last summer in the Swiss Alps in 1937, just before Laurent and Mathieu returned to their grandparents' townhouse in Paris so that they could continue their studies at the Lycée Pasteur. Cécile and Thierry stayed behind with Jean in the hopes that the mountain climate might help the bone tuberculosis in his spine. Penicillin didn't exist at that time; only the air might save him. "I remember just saying good-by, with no idea of how ill he was. But I recall the sound he made, as if he had some kind of intuition that it would be the last . . . mmm, like that . . . and that sound, to me, meant, 'Don't go. Don't go so fast. I don't want you two to go so fast. Stay longer.'"

Laurent and Mathieu were doing their homework in Paris one evening a few weeks later when their aunt approached them with a serious look on her face. She quietly told them. "Your father is very sick." Laurent instantly understood that Jean was dead. He stood, totally mute and helpless; Mathieu burst into tears. The date was October 16.

Their mother and Thierry quickly returned to Paris. Cécile was very dignified with her quiet tears. The funeral service was held at Père-Lachaise cemetery. Maurice de Brunhoff had died the previous year, Jean's mother some ten years earlier, but his brothers were all there. Laurent's strongest memory of the day is the way Dr. Sabouraud looked at his daughter, a thirty-three-year-old widow with three young sons.

"Life went on." They lived in the flat in Neuilly, with Laurent and Mathieu continuing to attend the lycée. Five months after Jean's death, Dr. Sabouraud died. What wounded Laurent as much as anything else was the emotion perhaps most unbearable to children: self-consciousness. "My English teacher, who became a famous novelist after the war, came up to me, and said, 'Alors, mon pauvre de Brunhoff, c'est la série noire.' La série noire: the dark series! He wanted to be nice, he wanted to say something, but I *hated* him for that. It made me cry in the middle of class, which embarrassed me."

The house in Chessy was sold. Then came the second world war. During Easter vacation of 1940, Cécile and the three boys were staying in Uncle Mio's house on the Loire, near Amboise, when the Germans occupied Paris. They went farther, to other cousins, until the end of the year. Then they returned to Neuilly, surviving the occupation as best they could, living as normally as possible, and enduring the cold and the bad food like everyone else. Tragedies continued; Michel de Brunhoff's twenty-year-old son, who was in the Resistance, was killed by Nazis.

Laurent and Mathieu were able to continue their educations throughout the war years. Then in 1944 Laurent, age nineteen, received his baccalaureate. He went to Montparnasse to study painting. Like his father, he enrolled in the Académie de la Grande Chaumière under Othon Friesz, and like his father he would soon enough draw elephants untouched by any of the tragedy that marked his own reality.

Continuation

The Work of Laurent de Brunhoff

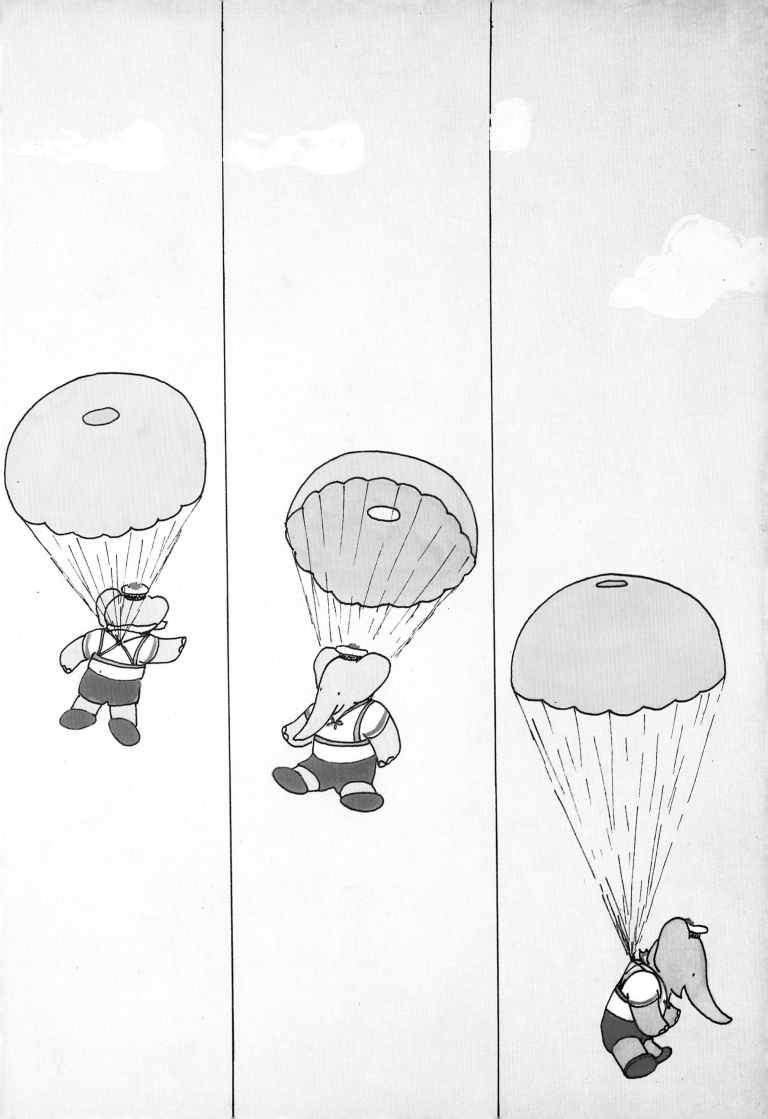

Laurent in Chessy, 1927 Laurent, 1949. Photo George Violon

Laurent, c. 1982. Photo Anne de Brunhoff

Preceding spread:
BABAR'S COUSIN: THAT RASCAL ARTHUR (1946)
Parachute Sequence
Watercolor and gouache on black-line proof, 40 × 58 cm (15½ × 23″)

The French like old favorites. They go to see them over and over again

to observe how time is treating them,

and if a performer appears to be in good health they are delighted.

A. J. Liebling[1]

I t must have been a moment of true revelation: the return to Babar. The decision to go back home, no matter how much one has loved that home, always has its trauma. In this case it meant not only reviving countless memories, but also radically altering a chosen course.

For Laurent de Brunhoff, that chosen course was abstract painting. Like most twenty-one-year-olds, he had embraced what was new and pioneering. In his youth he had learned the value of looking and painting; now he tore away at those activities with tastes far from those that had nurtured him. The training Laurent had at the Académie de la Grande Chaumière under Othon Friesz led him in a different direction than it had Jean. Laurent thought Friesz "a very attractive man, like a Normandy sailor," but artistically uninspiring. He admired more the avant-garde work of Manessier, Bazaine, Le Moal, and Estève, whose structured abstractions, "very delicate and organized," were being shown in the Salons de Mai. Soon his paintings in a similar vein were good enough for those salons, and in 1948 for a group show of young painters at the well-known Galerie Maeght in Paris. Manessier visited his studio and voiced approval.

Laurent had come to abstraction through a familiar route. At first he worked in the manners of Van Gogh and Cézanne, then with more of a Cubist approach. The few works that remain from his abstract years are very much in the French tradition, similar to the art of painters like Braque and Villon. Controlled and subtle, these paintings all have nature as their starting point. They are more formal and less self-revelatory than American Abstract Expressionism. A canvas based on bare winter trees in the Luxembourg Gardens has a quiet confidence. Laurent had neither the restlessness nor the impetuousness of many of his contemporaries; those qualities would come later, oddly enough when he was making books for children. Now he was comparatively tame, carefully and gently placing color and moving forms.

The work has self-assurance without arrogance. The hand of a true painter is apparent here—more than in his father's slightly static early paintings. But Jean and Laurent shared certain things from the start. Their work is a positive statement of their faith in painting and in the visible world. The subtly related forms of a canvas based on the port at Cassis reveal, somewhat in the manner of early Braque, a pier, drying net, and crane that are barely legible but nonetheless evocative of reality. A painting based on the chicken house near Cécile de Brunhoff's country house in Velannes is a far cry from Jean's views of Chessy, yet father and son clearly shared a penchant for grace and lightness.

Laurent made these three paintings after he had begun his own Babar books but before he had given up abstract painting. They illustrate both his first major artistic foray and the sensibilities that underlie his work for the books. His father, pre-Babar, had been the painter of quiet family scenes, of gentle watercolors and oils that were a bit like lyrical snapshots of everyday living; Laurent's early work was full of questing and probing, of visual and emotional movement, of venturing toward the new.

Untitled abstraction (Port at Cassis) (1949)
Oil on canvas, 73 × 116 cm (28¾ × 47″)

Untitled abstraction (Luxembourg Gardens) (1948)
Oil on canvas, 70 × 100 cm (27½ × 39½″)

Laurent's childhood had come to a more abrupt stop than most. First there was his father's death, then World War II. He had been allowed no gradual transition from boyhood to manhood. Rather, the first stage had been followed by a distinctly opposite second one. The initial embrace of abstraction had marked yet another abrupt turn. And then came the return to Babar.

We might imagine the scene in his simple atelier in Montparnasse, a few steps from the Académie. The young artist sits at his worktable. Perhaps he has just returned from a round of the most avant-garde galleries and a frugal lunch at a café. He could have been reading a Marxist newspaper as he ate. Facing him from his easel and all around the room are the highly charged abstract canvases on which he has been plugging away for weeks. Turning from them, he picks up a pencil and, as he has done often enough before, begins to sketch an elephant. Memories come back: the bedroom in Chessy, his father's studio at the end of the vast garden, the sight of a tall and smiling "Papa." At that moment Laurent's mind's eye might well have lit upon the scenes of Babar being outfitted in Paris, ballooning over the Mediterranean, bringing Father Christmas to the forest. The images of his father, and of Babar, and of himself could all have mingled.

Like so many of us, Laurent de Brunhoff wanted his childhood back—on his own terms. He had no need to wallow in his entire past. He wished mainly for Babar: his version. He was like a businessman's

Untitled abstraction (Chicken House) (1950)
Oil on canvas, 65 × 61 cm (25½ × 24″)

or craftsman's son who, after years of being educated and going his own way, returns to take over the family business and run it a bit differently. On one level his reviving Babar was clearly a return, to his father and his early youth; on another it was an assertion. Now he could take full charge of something that was an inherent part of him and handle it largely as he thought best. It was both a coming home and a rebellion.

Thierry de Brunhoff in time would also follow one of his parent's vocations. He became one of the foremost concert pianists in France. However, he eventually chose a very different course; at the age of forty he became a Benedictine monk, forsaking a brilliant musical career.

Laurent had always amused himself drawing little elephants; they were essential to him, no matter what else he was doing. He welcomed the return to familiar territory and wanted to give a second life to a childhood friend. He also enjoyed regaining elements of a father he had adored but with whom he may have still coveted a closeness that had never existed in reality. "To make Babar live was a way to make my father live. . . . I certainly *loved* him, but I have no memory of our personal relationship being very deep. I remember the general atmosphere, but no clear father/son involvement." Now perhaps he could obtain connections previously denied.

Laurent's first book, *Babar's Cousin: That Rascal Arthur,* was published in 1946. Jean de Brunhoff's protagonist had been, appropriately, a father figure; Laurent's, naturally enough, was more of a child. Arthur, in fact, is roughly Babar's contemporary—he is the king's cousin and Celeste's brother—but unlike Celeste he has never grown up. Laurent's Arthur is precisely as Jean left him. He is like an adventurous son—a dreamer and borderline ne'er-do-well who goes off recklessly but ends up on his feet and safely back within the warm security of his family. "Whereas Jean de Brunhoff had taken inspiration from his own family in detailing the adventures of Babar, I featured Arthur because I identified most easily with him. I was barely twenty-one with no family of my own; I felt I had a lot in common with the teenage Arthur."[2] And so Laurent wrote a book about a rascal.

Babar's Cousin: That Rascal Arthur opens on a touching note. In the characteristic handwritten script, there is a dedication "to the memory of my father, Jean de Brunhoff," opposite a lovely scene of a perfect and complete family: a mother and father, three children, their favorite cousin, and friends. For Babar readers, as for the artist, these presences made the book a bit of the past recaptured. So does the underlying character of the story line: tranquillity and plenitude followed by crisis-laden adventures that conclude with a calm solution and ultimate homecoming. Laurent de Brunhoff brought back Babar with tremendous authority and authenticity.

The illustrations for *Babar's Cousin* have what Laurent today calls remarkable "faithfulness to the father style." Having done those elephant drawings over the years and colored his father's, he knew how to get it all right. In this and the following books, there is sufficient consistency with Jean de Brunhoff's work so that a large segment of the audience for the Babar books *still* does not realize that they have had two creators. Laurent de Brunhoff periodically meets someone who expresses surprise at how young he looks given that he supposedly wrote his first book in 1931. Starting with *Babar's Cousin,* Laurent's Babar, as well as the rest of the cast of characters, have been, above all, as they always were. Laurent feels that "the drawings for this first book were very awkward compared to my father's work," but most of the larger audience for Babar scarcely recognized the difference.

Under close observation, however, Laurent's art differs distinctly from his father's. Contrasts exist in spite of the infallible way that he has upheld the tradition of Babar through its characters and settings and maintained its essential personality. Look at *Babar's Cousin: That Rascal Arthur* next to *The Story of Babar* and you see brighter colors and more angularity. Laurent's illustrations are more obviously watercolors in their free brushwork and the varying degrees of paint saturation. Painterly qualities have become more important than narrative ones. There is a new look of spontaneity; Laurent's major scenes appear to have been made rapidly, while Jean's look lingered upon. The life of the pictures in *Arthur* is in their overall effect—highly charged, fluid, and animated—while the richness of Jean's work is more in the detail and the incredible amount of information that is packed into each illustration. A characteristic Jean de Brunhoff scene includes the full range of objects that were in Babar's steamer trunk or every possible cake available in a pastry shop. What is remarkable in Laurent's images is not the number of specifics so much as the spirit and movement of the landscape, the massing of the forms, and the expressive power of the brushwork.

Laurent's art—from *Arthur* through his most recent books—often reaches further than his father's. Consistent with that, it sometimes lacks the immaculateness and the nuances of the elder de Brunhoff's. Laurent's line often isn't as finely honed as Jean's. The designs are not quite as precise. If the father delighted in creating order, the son sometimes teeters, deliberately, on the edge of disorder; one organizes complexity meticulously, while the other accedes more to that complexity and even savors it. Jean's achievement is that of someone safely positioned in a world in which everything had its rightful place, where there was a lot of time and space to concentrate on the niceties of life. He evoked the comfort and security of upper-middle-class French life of the 1920s and 30s with all the concomitant luxuries, rules, and mental habits. Laurent was more a product of the restless postwar era, the period of Sartre, Camus, and abstract art. His yearnings are more exotic, his artistic technique more innovative. In the father's books Babar's most significant travels are from forest to civilization; he—and Zephir—visit some treacherous places, but somehow the key moment is always their arrival in tame cities or their own nice homes. The father's stories extol the merits of orderly living. The magic of the son's volumes is more in the departure from the safe and familiar. Distant islands, outer space, mysterious grottoes: it is with uncharted territory—perhaps forbidden, often terrifying—that the author most surely hits his stride. With Jean de Brunhoff, we marvel most often at places that offer a sense of security, be it to elephants or to the de Brunhoffs themselves: Celesteville, Paris, Île-de-France, the Alps. With Laurent, we are moved above all by what is foreign and distant, and somewhat new. There are few better examples of this than his eventual depiction of the place that in French eyes is about as astounding and farfetched as you can get: America.

BABAR'S COUSIN: THAT RASCAL ARTHUR (1946)
The Celesteville Train Station (preliminary sketch)
Watercolor, 27 × 36 cm (10½ × 14″)

Hachette had Laurent de Brunhoff use the same working method that had been employed for all of Jean's books after the first two. This meant first supplying the printer with a final line drawing, and then at a later stage hand-coloring a printed proof from that drawing. The technique changed in 1963 when Random House became Laurent's primary publisher and had him do the original drawing in color; until that time, however, his "pleasure as a painter was the early version, more than in the color I was doing on the black-line proof." Not yet entirely confident of his skills at presenting his characters and settings, he needed the preliminary stages to work things out. The visible thinking process and spontaneity give that preparatory work tremendous life and immediacy. Laurent's abilities as a young artist shine even more in the watercolor sketches for the illustrations of his early books than in the printed pages of the books themselves.

Consider the opening two-page spread from *Babar's Cousin: That Rascal Arthur.* It is of the Celesteville train station—the departure point for the vacation that Babar and Celeste, their children, Zephir, and Arthur are all taking together. In the final, hand-colored line proof, Laurent needed above all to convince viewers that Babar was irrefutably back. The elephant had to be not a day older than he had been in the earlier books, unchanged in looks and character. The illustration succeeds. A worldly and dapper Babar, a perky adorable Arthur, and a supporting cast of characters are drawn and colored

BABAR'S COUSIN: THAT RASCAL ARTHUR (1946)
Kangaroos (preliminary sketch)
Watercolor, 37 × 27 cm (14½ × 10½″)

almost exactly as they had been ten to fifteen years earlier. In print, Laurent achieved his desired continuity. But in the side of his work not intended for public consumption—the preliminary watercolor for that two-page spread—he showed himself more of a true experimenter. Trying different colors and nuances of position with the goal of articulating and balancing the elements, he made a dazzling foray. It brings us face to face with the moment of creation, with Laurent's highly charged dialogue with painting. What emerges is his ongoing quest for encapsulating the subject while maintaining rhythm and flow. He was also exploring its sort of action—vigorous but carefully modulated—in his abstraction.

These are the qualities of the best of his watercolor sketches from that time forward. His technique sure, he establishes his subject with utmost clarity at no cost to a disarming spontaneity. In this study of the train station, he attended diligently to his task as an illustrator, meticulously articulating the setting and crowd, at the same time remaining all painter, giving himself to the pleasures of his brushwork and the voices of color. We feel the space of a typical European train station. We can apprehend its protective shelter adjacent to open-air tracks; we taste the sooty air. At the same time we can share Laurent de Brunhoff's rapture with the processes of art.

Laurent makes Arthur into a rascal indeed. Babar's cousin is a more determined and inventive troublemaker than any of Jean de Brunhoff's characters. While the rest of the vacationers innocently fish and go crabbing, Arthur sneaks onto the tail of an airplane. The plane takes off, and he is saved in a trunk-to-trunk rescue initiated by an elephant passenger on board. Laurent's story then takes a course of risks and dangers more extreme than any in his father's tales. Jean's plots are those of a young father, temperamentally calm, ever cognizant of the need not to go too far. We always feel that limits have been set and that an example is being made. The naughtiness is there mainly as a ploy to lead back to safety. With Laurent, the mischief and desire for the new are more key. This is true not only in what he created as a young and independent twenty-one-year-old, but also later on, after he too became a husband and father. In his most recent full-scale book to date, *Babar's Little Girl,* he has the child pretend to hitchhike. That's hardly model behavior. And even that was a compromise with the publishers. Initially Laurent had Isabelle actually hitchhiking; he changed it to pretending when his editors explained that he could not set such a dangerous example for his young readers. Whereas Jean de Brunhoff's characters get into trouble mostly through happenstance, Laurent's end up there as a result of their personalities. Literally and visually, the son's work touches more extremes than his father's while focusing a bit less tenderly on the present. Restlessness infuses the story line and the brushwork equally. The tone of the tales is well established by the high-keyed colors.

In a more dire turn of events than would have occurred in one of Jean's books, the pilot of a plane, a cranky rhinoceros, ejects Arthur out of the aircraft. On the other hand, the plot still has its edge of safety. Arthur conveniently parachutes to earth. The hand-colored black-line proof of that descent shows just how competent Laurent de Brunhoff was at following the rules of his new task. The original painting has faded considerably—the blue of the sky has practically disappeared, and the variables of

Arthur's gray elephant skin are gone—but it remains an impressive achievement. Each stage of the fall is articulated perfectly. Laurent could show an elephant tumbling, sitting, pulling himself up, and carefully letting himself go. He knew the turns of trunk, mouth, and eyes needed to paralyze his subject with agonizing fear or charge him with happy anticipation. He had an easy mastery of details like the parachute itself. And he had a rare gift of concentration. Not as inclined to fill all the space as his father was, Laurent de Brunhoff generally presented less information but focused more on—to put it extremely—the existential experience of his protagonists. We sharply feel Arthur's trauma and his relief. "Arthur's Fall" presents an event alien to most people's usual experience, but the intense emotions are highly recognizable.

What makes the parachute sequence so effective are the variations in body position. The difference between tension and relaxation is palpable. That eye for the telling nature of posture is one of the ways in which Laurent most successfully carried forward his father's tradition. Both artists readily evoked the volumes that are spoken by the way we comport ourselves physically. So with the elephants—the curve of the trunk, the precise position of the head, the angle of the tusks, the exact stance, the way hands (or, if you prefer, front feet) are held: all denote mental states and attitudes. Stance alone can indicate humility or arrogance, complacency or feistiness.

Arthur has a nice encounter with some kangaroos. This is a new species of animal in the Babar repertory, and Laurent does very well with it. Hasty as the brushwork looks in an early watercolor sketch of kangaroos in the woods, it clearly evokes the subject matter. The firmly drawn trees suggest a permanence and stability that is a suitable foil to the flurry of kangaroos. Straight lines counter curves. Rigid tree trunks play against the more amorphous forms of the animals. As a result, the kangaroos' animation is all the more salient. Their playfulness and spirit emerge in full force.

After leaving the kangaroos, Arthur hitches a ride on a freight car. Some monkeys then uncouple it to trick him. Stranded, he luckily encounters two dromedaries. The scene of Babar's young cousin on the riverbank, as he first glimpses those dromedaries, is like a vision of the promised land. Laurent de Brunhoff has said that Babar is his means of heading toward utopia; this illustration is the first of what has now been more than forty years' of images of that utopia. For one thing, Arthur is the essence of youth and hopefulness. We can't see his face, but we know he has total confidence that smooth sailing and salvation lie ahead. Not only do the characters in these books avoid any trace of aging, they also retain completely the faith and optimism that goes with a happy childhood. It's the fulfillment of the dream in so much of children's literature—Peter Pan's refusal to grow up. Another utopian factor is the paradisiacal landscape. Such settings proliferate in Laurent de Brunhoff's work—from *Arthur* on. However laden with treachery his stories may be, Laurent always offers the respite of images of unblemished earthly tranquility. Lush and flawless landscapes counter life's anxieties.

BABAR'S COUSIN: THAT RASCAL ARTHUR (1946)
Arthur on the Riverbank (study)
Watercolor and pencil, 22.5 × 25 cm (9 × 10″)

Perfect, of course, that Laurent's first image of earthly paradise should be at the side of a river. Not only did he spend some of the happiest hours of his youth along the banks of the Marne, but that specific scenery is one of the splendors of the initial *Story of Babar.* De Brunhoff *père* and *fils* were both nourished by the sight of rivers. Yet they treated them differently. Jean's work shows the river as the locus of many forms of recreation; Laurent's is less rich in illustrative detail, but by being pared down it focuses more on the landscape elements and their effect. Jean de Brunhoff found paradise right in the neighborhood, in scenes that were distinctly part of his family's everyday reality. Laurent, on the other hand, has put Arthur on a riverbank in a remote, entirely imaginary location.

The illustration on this page is an early watercolor of the scene, while on page 103 is the final version that Laurent made before doing the line drawing that the printer in turn proofed for him to color. Each has its advantages. The large palm tree has a particular freshness in the preliminary effort, but a truer palm tree character—like the synopsis of an idea—in the finished one. The ethereal and poignant ambience of the more impromptu version is traded, to a degree, for the increased clarity and

BABAR'S COUSIN: THAT RASCAL ARTHUR (1946)
Arthur on the Riverbank
Watercolor and ink, 22 × 25 cm (8½ × 10″)

illustrative power of the later one. When Laurent adds details and fine-tunes his subject, he provides knowingly for the needs of his readers. The quality of air and of atmospheric light give the early watercolor sketch its salient character; the specifics of things mark the later stage. If in the second watercolor we miss the admirable animation of the dromedaries in the first, it is the final rendering of the dromedaries that makes us smile and that enables even a six-year-old to know intuitively what he is looking at. Oddly enough, the final version is the funnier. One might expect humor to depend on spontaneity but, in fact, it derives from details, and in this instance on the defining powers of thin black lines. Little touches, like the bird on the grass, make Arthur's elephantness all the more palpable and amusing. He seems more massive. His pom-pom now has a fringe to it. His cap is now wonderfully ludicrous. Even the palm trees in the background have become amusing little characters, a sort of comedic chorus line.

The dromedaries agree to give Arthur a ride back to his family. This paves the way for a spectacular fantasy. The dromedaries need to cross a river loaded with ferocious crocodiles, and some hippo-

potami gallantly make a bridge for them. The passage across that bridge is one of Laurent de Brunhoff's finest inventions. The hippos, facing in opposing directions, are arranged like stepping stones. The dromedaries step securely on their backs as threatening crocodiles lurk left and right. A small red bird sits atop one dromedary; Arthur, with a look of apprehension, on the other. He has the confidence, ingenuity, and good luck essential to surmounting obstacles inherent in life. Arthur enjoys sanctuary in the midst of clear and prevalent danger, which is a large part of what these books are about.

The two-page spread of the hippopotamus bridge is a riveting, imaginative scene in the book—with a particularly lovely passage of pale mauves, greens, and blues in the river—but the preliminary watercolor is even more extraordinary. In it, the crocodile heads are true feats of painting. Those abstracted grisly jaws, painted as simply as possible, are open at just the right angle to make them lethal gullets. Their suitably intense black is outlined in a harrowing green, rendered especially effective by the surrounding white paper. The pleasant forms and graceful bearing of the camels make them the perfect foil to that palpable danger.

The painting is a profound reminder of how empowering an act walking is. The nobility of movement—and the significance of strong, well-functioning legs—emerges here with an intensity expected more from art on the level of Giacometti's figures. This is an intrepid, and at the same time fortunate, crossing over treacherous territory toward home and safety. And it is made against a natural setting of sunny, tropical colors that renders the scene quite romantic.

Arthur combines mischief, optimism, and self-assuredness with a well-warranted bit of abject terror. He emotes all the feelings that suit his adventurousness, and perhaps aspects of Laurent's own growing up. He is brave, but he also needs to place his confidence in others. He is blessed that his dependency is placed on such kindly creatures. This naughty character is above all an innocent who needs protection. His roundness accentuates his innocence. The form is a serene contrast to the threatening arrowhead angles of the crocodiles' jaws. The playful white and red of his clothing and the soft gray of his skin are the colors of childhood, especially in comparison to the angry black and green nearby. (The white and red belong, of course, to the sailor suit in which Jean de Brunhoff first dressed Arthur. It is Jean's sort of detail: the essence of seaside living in France.) The dromedaries, too, have a color that befits their character. Not only is their pale ocher factually accurate for camels, but its calm and placid tone is reassuring. The quiet perseverance and tenacity that are the requisites for surmounting evil throughout the Babar books are evoked by every visual means.

Easier times follow. Arthur rests serenely with the dromedaries as his guardians. They take him to an Arab village where he has a surprising reunion with Babar. Babar eventually drives him home in a tractor, and there the whole family greets him in a second happy reunion scene. Reunions—with father figures and with one's entire family—are, after all, what this book is about.

The revival of the Babar books was applauded. If for Laurent it was like a partial homecoming to his childhood and to his father, for France it was the reappearance of a national hero. America, too, was overjoyed. As with previous Babar books, Random House was the publisher of the English language edition of Babar's Cousin: That Rascal Arthur, with Merle Haas translating. Nothing was more natural than for Jean de Brunhoff's son to see to the well-being of the ageless royal family of Celesteville, and a loyal public celebrated accordingly.

BABAR'S COUSIN: THAT RASCAL ARTHUR (1946)
Arthur with the Dromedaries
Watercolor on black-line proof, 14 × 24 cm (5½ × 9½″)

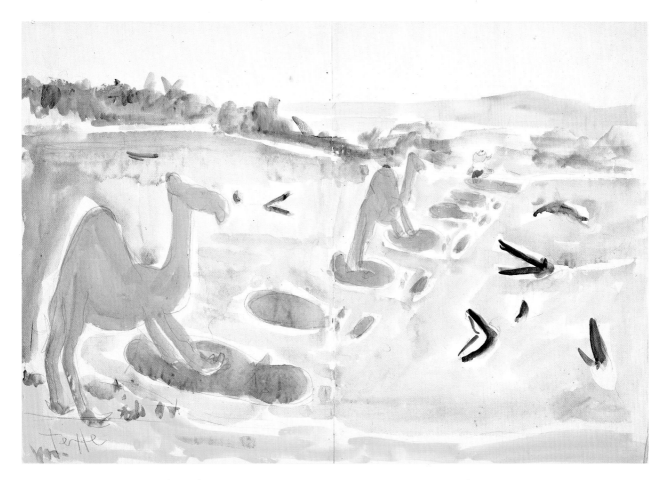

BABAR'S COUSIN: THAT RASCAL ARTHUR (1946)
Hippopotamus Bridge (study)
Watercolor and pencil, 36 × 53 cm (14 × 21″)

BABAR'S PICNIC (1949)

Planning the Picnic

Watercolor and ink collage, 36 × 55 cm (14 × 21¾″)

Cécile de Brunhoff was as pleased as the broader audience was. Hachette had initially asked her if she would continue the series after Jean's death. She had replied no; the elephant had died with her husband. But Laurent's revival of Babar struck her as "completely natural." It was a logical progression from his doing the colors of his father's last books. She had seen him draw elephants ever since he was very young. Of her three sons, he was most like Jean and had been most interested in what their father was doing. There was no question that if anyone could carry on the Babar tradition, Laurent was the one.

Even if the de Brunhoffs's elephants wear clothes, they have never been subject to the usual vicissitudes of human life. In Jean de Brunhoff's books, Babar and Celeste married and had children without appearing to age so much as a day. Once their children got past infancy, they reached the age at which they would always stay. In Laurent's books, Babar and his family have continued to remain unmarked by passing time. Since *Babar's Cousin: That Rascal Arthur,* Laurent has for over forty years created Babar books at an average pace of one every year or two, in a timeless universe in which no one grows older and death never occurs. Children's fiction offered him a splendid reprieve from the sort of reality he had begun to experience all too painfully at the age of twelve.

His second book, however, eventually proved problematic in other ways. This was *Babar's Picnic,* the book now out of print because of its stereotypical portrayal of spear-carrying black natives. Although Laurent feels that some of the art depicting those natives represents enormous strides in his technique as a painter, he will no longer exhibit it. But some impressive watercolors can still be seen, including a collage for the first two-page spread. Here Zephir is consulting Babar, Celeste, and General Cornelius about the picnic, while Arthur reads a map and Pom, Flora, and Alexander pack their Indian suits for the outing. Laurent had originally given the setting a solid red rug, but this collage enabled him to visualize the characters with the lighter and freer herringbone pattern underfoot. The new rug improves the ambience measurably. Its lines charge up the scene with playful motion and give the picnic preparations a fever pitch. This is a great moment. The young elephants stuffing a backpack have the total eagerness of human children before such an outing. Everyone goes about his activity in the glow of a convincingly smokey and warm fire. The flames blazing in the oversized hearth have the thrusts and counter thrusts of Laurent's abstract paintings; they succeed both as general evocations of energy and as specific illustrations of fire. And the scene out the window, with its red bird and palm tree, is a powerful reminder that we are still very much in that world we first entered with the original *Story of Babar. Plus ça change, plus c'est la même chose.*

Flora goes to a marketplace to buy cakes for the picnic. Enchanted by the open markets he had seen on a recent trip to Rome, Laurent snatched the opportunity to take his characters to such a spot. A little watercolor of Flora's expedition delicately evokes the setting. This isn't quite the final form of the illustration, but it is very close to it. It's the last version Laurent made before doing the uncolored black-line drawing that he gave to the printer for proofing. What distinguishes this painting aren't so much Laurent's qualities as an abstractionist—or the other factors that differentiate him from Jean de Brunhoff—as the aspects that make him the perfect perpetuator of Babar. Like his father, Laurent gives his elephants great spirit; look at the jaunty gait of the happy shopper holding a basket. Posture and comportment tell all—Flora's face is not visible, but her stance and the position of her arm render her

terrifically eager. Bearing gives fatigue to the elephant selling wares in the right foreground, aggressiveness to the vegetable peddler on the left. These depictions occur within a well-ordered composition to which the arrangement of the umbrellas imparts a lively rhythm.

Laurent had learned his lessons well. But he also developed his own way of doing things. As had his father, he scrutinizes everyday life astutely, but he uses different means to convey his observations. In portraying photographers and shopkeepers serving wealthy Parisians, or passengers disembarking from an ocean liner, Jean invariably included every possible detail. For this market scene, he would have elaborated on the fabrics of the elephants' coats. There are scenes by the elder de Brunhoff in which we feel as if we can see every thread, while Laurent simply suggests textures and surfaces. He has loosely filled in the plaid of one shopper's suit in much the way that he gave patterns to those draperies he colored at age thirteen for the posthumous edition of *Babar and His Children*. Where Jean elaborates, Laurent generalizes. He makes the distinction between affluent clients and struggling salespeople more through impression than exactitude, applying his watercolor in just the right way to suggest mink and velvet on the better-heeled shoppers, and a loud red-and-white-striped cotton on that pushy vegetable peddler. Consider, too, the wares on the ground. Laurent gets the essence of knives, a funnel, and stacked pots. The objects ring with authenticity. But unlike his father he leaves out their precise finishes or the designs of their handles.

Both de Brunhoffs specialized in extraordinary methods of transportation. Besides making ordi-

BABAR'S PICNIC (1949)
Flora at the Marketplace (study)
Watercolor, 15 × 25.5 cm (6 × 10″)

BABAR'S PICNIC (1949)
Roadster Drawn by Marabous (study)
Watercolor, 36 × 27 cm (14 × 10½″)

nary cars magical, they have invented many forms of animal-drawn vehicles. The great one in *Babar's Picnic* is a roadster pulled by two marabous. A watercolor sketch shows it in an early, raw stage, the embodiment of speed and high adventure even if it doesn't yet have the black lines needed to clarify and define it for young viewers. This lean, powerful image further signals the magnitude of Laurent's boldness and his unmitigated passion for visible motion. The furious beating of the birds' wings is almost audible. Laurent would not discover the paintings of Willem de Kooning for another twenty years, but their energy and vigor were his by instinct.

When the de Brunhoff clan talks about the salient qualities of Laurent's work, the book they invariably refer to is his third: *Babar's Visit to Bird Island* of 1951. His mother and brother consider it his most original. It prompted Cécile's evaluation that "he pushed the Babar series further than his father had." It caused Uncle Mio to label Laurent more of an artist than Jean. He was engaged in more of a search. Laurent eschews such comparisons, but by his own evaluation more than thirty-five years later, his watercolors for *Bird Island* are some of "the most successful, the most original" he has ever made.

The title of the book does better untranslated. In French it is *Babar dans l'Île aux Oiseaux,* which moves from soft, babylike sounds—over which the tongue glides lightly—to "z" sounds that whiz like propeller blades. What was suggested by the towing marabous in *Babar's Picnic* here takes on new scale. All the stops are pulled: in line, color, and temperament. If exoticism in *The Story of Babar* was most often confined to Persian rugs and potted palms, here it takes the form of enormous, fantastic birds, feathered capes, and ships in high winds. Laurent de Brunhoff's vision is a deeply Romantic one. In the Arab scenes of *Babar's Cousin* he had clearly felt the call of the Orient of Delacroix and Matisse; now the beckoning power of lush and distant places is even greater. There is a Fauve-like intensity to the scenes. The story aside, the illustrations convey both the potency of nature and a rapturous response to it.

Laurent was the true inheritor of both of his parents' imagination. He too invented extraordinary ways for animals to behave. At the opening of *Bird Island,* Babar's three children, out on an ordinary walk, just happen to encounter a white boat occupied by two large, highly colored "échassiers"—the translation is "wading birds"—and a bright green duck. They have a fantastic experience within a

typical de Brunhoff framework: a rule-abiding world that keeps the Babar books both instructive to youngsters and reflective of most children's reality. Pom, Flora, and Alexander may have decided to take a walk, but they have had to eat their breakfast first. Arthur and Zephir miss out on the outing because they are late. That sort of normalcy thrown in, exceptional things happen. The duck asks where King Babar is. And the excitement engendered by the idea of a talking duck is magnified by some thrilling painting. The images are bold, simplified, and loaded with power. There isn't the smallest vignette in this book that doesn't have a surcharge of energy. When the elephant children take the duck in a boat to their father, even the green and blue waves are full of eagerness. Somewhat in the manner of Japanese prints, those waves transform water into magic: the miraculous vehicle for travel, swift and mysterious, its chemistry and color ultimately beyond fathoming.

The purpose of the birds' visit is to extend an invitation for Babar and his family to visit their island. Except for the Old Lady, who is afraid of seasickness, and Zephir, who stays behind to keep her company, all of the familiar characters make the trip. It is reassuring to Babar aficionados to see the full cast in attendance: General Cornelius, Céleste, and Arthur, along with Pom, Flora, Alexander, and Babar himself. All the key players are accounted for, and no one has changed an iota.

Color and brushwork make their voyage a dramatic emotional experience. The vivid yellow greens, oranges, and celestial blues inspire both excitement and apprehension. Two watercolor sketches for the two-page spread of the bird fireworks—"The Elephants' Arrival on the Island"—clearly state the facts of the scene, yet are almost entirely abstract. Both works appear so spontaneous that it is as if we are witnessing the actual moment of invention of the spectacular method of flying. The dramatic handling of paint captures the thrill of both the airborne movement of the birds and of Laurent's own imagination. The operatic colors are as fierce as in the most fiery Fauve canvases. The brushwork emulates the freedom of birds to sweep high and low—and the spiritual liberation possible through the making of art. But for all the leaps, there is a clarity. That blend is apparent on a smaller scale in the almost frantic, yet completely articulate, black lines that denote foliage on the mountain.

Laurent de Brunhoff makes us feel the essence of his subject: the flurry of beating wings, the bemused anticipation of two baby elephants astride two gigantic and powerful birds. The colors encourage us toward high-pitched feelings about the miracle of flight in general, in all its forms. Unfortunately, the final hand-colored black-line proofs for this book have been lost. But what we see in the final book is also very moving. The preliminary watercolors have an unmatched ferocity and spontaneity, but the printed illustrations—less about paint, more about the details of the scene—also have great life. Given the requisites of his task to make the subject matter entirely recognizable to readers of all ages, de Brunhoff has kept the picture highly dramatic.

The elephants land on Bird Island. They witness a ballet performed by cranes, welcome respite after the tumultuous journey. Laurent's watercolor sketch for it has the lightness of the most ethereal passages of *Swan Lake*. It is a gentle minuet of brushstrokes. Next, the elephants receive wonderful clothing made of feathers. If Jean de Brunhoff dressed his characters in the finest Continental tailoring and surrounded them with the quintessential accoutrements of urbanity, Laurent has them don outrageous robes in the midst of a jungle. The plants there have fantastic large leaves, some of which resemble Matisse's rendering of mimosas. Encountering further ostriches and marabous, the elephants

BABAR'S VISIT TO BIRD ISLAND (1951)
The Elephants' Arrival on the Island (I) (study)
Watercolor, 29.7 × 51.5 cm (11¾ × 20¼″)
Collection Larry and Jacqueline Hanson

BABAR'S VISIT TO BIRD ISLAND (1951)
The Elephants' Arrival on the Island (II) (study)
Watercolor, 36.4 × 56 cm (14½ × 22″)

BABAR'S VISIT TO BIRD ISLAND (1951)
The Ostrich Race (study)
Watercolor, 33 × 52.5 cm (13 × 21¾″)

BABAR'S VISIT TO BIRD ISLAND (1951)
The Cranes' Ballet (study)
Watercolor, 25 × 27 cm (10 × 10½″)

seem like cultivated urbanites by comparison, a switch from their role in the earlier books where they were the creatures in need of refinement.

In other ways, however, Laurent maintains the Babar tradition. Like his father, he elaborates the pleasures of daily living. First there is food: ostriches process honey, pelicans make spice cake, herons make liqueur. It all looks and sounds delicious. Then there is a great public spectacle. Everyone rushes to see an ostrich race that the elephants watch from a tree branch. Popular forms of entertainment figure in most of the Babar books: in Jean's art, events like the circus and opera; in Laurent's, occasions like this race of ostrich-drawn chariots won by the green duck, and the drive-in movie Babar will attend in Los Angeles. Laurent puts his own imaginative twist on familiar elements.

The elephants do some recreational sailing. They fish a bit en route, and Flora catches a shark who eats the green duck. Eventually the elephants cut open the shark, free the duck, and feast on the remains of the great fish. In a vigorous sketch for their outdoor banquet, the lanterns at night look

BABAR'S VISIT TO BIRD ISLAND (1951)
Outdoor Banquet (study)
Watercolor, 24 × 28 cm (9½ × 11″)

magical. Yellow paint becomes the essence of light itself. Broad black strokes make the tree trunks powerful living presences. De Brunhoff's rendition of nature is again a deeply felt Romantic vision. The splendid final scene shows the elephants departing while three of the most exotic birds watch. A watercolor sketch for the departure captures the essential drama of ships setting sail for the high seas, and has the bittersweet poignancy we have come to expect from the conclusions of these books.

Later in the 1950s Laurent's abstractions, completely unrelated to his Babar work, went through what he terms his "Klee phase." His Babar style in no way resembles Klee's, but what shows of an earlier affinity for Klee in this last scene of *Bird Island* is a feeling for eternal mystery. A two-inch-high band of starry night becomes the entire universe, comforting yet unfathomable. The sea is the suggestive sea of poets and philosophers. And the distant elephants and nearer green duck and ostriches express the blend of feelings universally associated with leaving one phase of life and moving on: tenacity and resignation, stolidness as well as sadness at the passing of time.

The illustrations for *Bird Island* have, even more than those in Laurent's first two books, a second-generation freedom and spontaneity. Laurent's application of paint is looser, and seemingly less painstaking, than in his own early work or in any of his father's. The colors are more complex; blue water is charged with soft green. Landscape and characters are a bit more fantastic. Jean's gentle elaborations have been exchanged for these developments of Laurent, and Jean's focusing on nuance has now been supplanted, even more than in Laurent's previous two books, by the probing of raw emotion. The green duck and fantastically colored ostriches are less illustration than transports of the mind. The seas are rougher, the landscape deeper. Colors sparkle exotically. Compact forms have given way to furious brushwork. The plot may be less developed than in some of Jean's books, the crisis and resolution less intricate, but the painting has a new vibrancy.

Laurent's concentration on the inner life represents a leap beyond his father's achievement. He enjoys that luxury of people with parents who have already accomplished a great deal; rather than having to start from scratch and discover art on his own, he augments an existing achievement. Benefiting from a whole world and cast of characters that was already invented for him, he could focus more on the psyches of the characters—their thrills and anxieties and dreams—and less on the details that surrounded them. Whereas Jean recorded settings largely as collections of enormously charming facts—potted palms, footrests, trays of pastry—Laurent used surroundings more to echo the emotions of a scene. Intensity of feeling had been the strength of his painting method from the start: consider the smooth surfaces and gentle hues of the utopian river scene in *Cousin Arthur,* and the fever-pitch excitement of the planning scene with the herringbone rug in *Babar's Picnic.* In *Bird Island* he has taken the imprint of his loaded brush and the vibrancy of color to a new extreme.

Were Jean de Brunhoff to have painted the island the birds live on, he probably would have shown nests with draperies in the windows. Inside we might have seen the vessels for serving worms, and bird beds the likes of which no one else could imagine. They would have been rendered in his exacting and meticulous style. Laurent, on the other hand, concentrates more on the thickness of the tropical foliage, the general impressions of island life. It is not that he isn't full of smaller inventions as well—there are beehives, ostrich-drawn chariots, and those great feather costumes—but he has not delved as thoroughly, or with as fine-pointed a brush, into every detail. Roger van der Weyden painted woodwork and landscape backgrounds not totally unlike Jan van Eyck's; he did not, however, include as many figures and houses that under a magnifying glass betray every crack and crevice and bit of ornament. This isn't to say that van der Weyden was better or worse than van Eyck, or Laurent de Brunhoff better or worse than Jean. Jean's renderings are exquisite. It is the details that give his illustrations their richness and allure. Laurent's are strong in a different way, gaining their profundity more from their groping with mysterious, and perhaps universal, cerebral issues.

If Rubens's *Helena Fourment and Her Children* was one of Jean's models, it fits that *The Pastoral Concert* at the Louvre was one of Laurent's. (The painting was labeled a Giorgione at the time that Laurent copied it, but the attribution has changed since to Titian. Laurent, however, still thinks of it as a Giorgione, feeling that it lacks the brushed texture of a Titian.) *The Pastoral Concert* misses the quiet tenderness of *Helena Fourment* but is a tougher, more daring picture. The subject matter is more robust, the underlying emotions bolder and more out in the open. What attracted Laurent were the

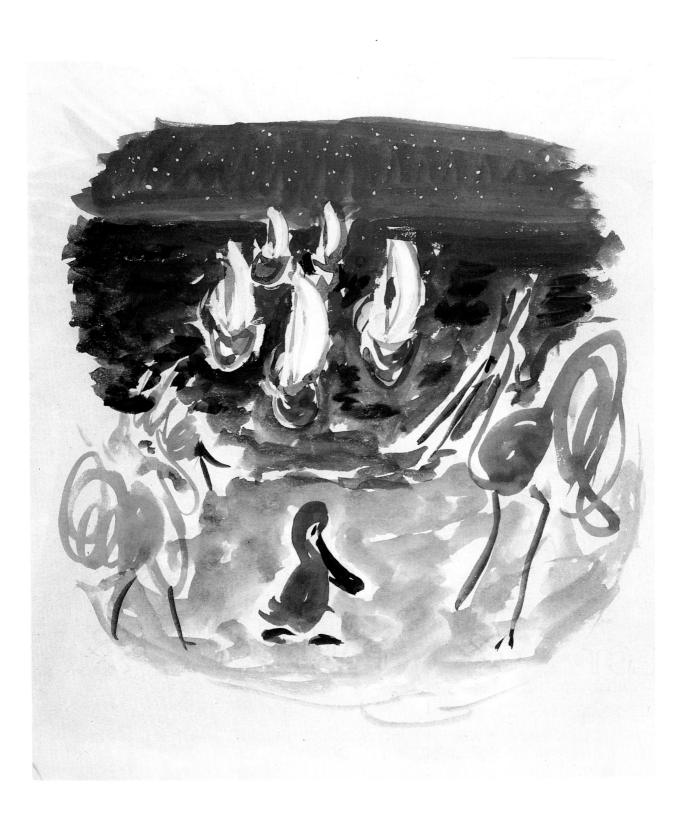

BABAR'S VISIT TO BIRD ISLAND (1951)
The Farewell (study)
Watercolor, 23 × 23 cm (9 × 9″)

TITIAN (GIORGIONE?)
The Pastoral Concert (c. 1509–10)
Oil on canvas, 105 × 136 cm (41½ × 53½″)

clarity of the volumes and the strength of the forms. The composition of unifying curves exemplified the decisiveness he was looking for in his own work.

Given their differences — in temperament as well as style and date — the Rubens and Titian also share a great deal. Their mutual traits parallel what Jean's and Laurent's work have in common. These paintings are traditionally beautiful, ingratiating to the eye. They celebrate splendid moments full of visible light. This suffusion of richness is the result of tremendous control and discipline. Both are technically impeccable; the paint has been applied meticulously, the forms and colors synchronized carefully, the subject matter presented clearly. Rubens and Titian have used every means at their disposal to evoke earthly perfection, be it in the form of a touching family moment or an imaginary image of music, nature, and sensualism. It is not hard to see why these were paintings to which Jean and Laurent de Brunhoff would return time and again.

Outside of the Babar arena, Laurent's painting had taken a surprising course. Influenced by leftist theory, he craved art that could be "understood by the general public. So I condemned abstraction, and tried to make figurative paintings, of peasants in a landscape, fishermen eating in a little house, and so on." But he quickly moved from this social realism back toward abstraction in a style, he says, that was influenced quite a bit by Klee. Then, at the end of the 1950s, he abandoned all painting other than his Babar work. "I finally had to make a choice. I couldn't live two lives." He proceeded contentedly without doing other forms of painting until the mid-1970s. As for his ideal of an art that could be understood by the broad population, he could not have found a better means of achieving that goal than the Babar series itself.

Laurent de Brunhoff married in 1951. Until the dissolution of their marriage in the mid-1980s, his wife Marie-Claude was to be deeply involved with his work, both by championing it and offering frequent suggestions on the plots. In 1952 their daughter Anne was born. Having lived in the Montparnasse studio until their baby's birth, they now moved into Cécile de Brunhoff's country house in Velannes, some forty-five kilometers outside of Paris. It was there that Laurent wrote *Babar's Fair,* published in 1954. Its plot and art are a bit calmer than those of *Bird Island,* but it still contains some of Laurent's most vivid illustrations. The book opens with a lively depiction of a council meeting of the chief ministers of Celesteville. There is a rich play of patterns: stripes against checks, and both of them against the swirl on the floor. That floor design succeeds as both an important-looking Oriental rug and a rather free and abandoned abstract painting. In this cultivated, animated setting, the elephants are an impressive group, each with his own effective detail: lorgnette, wire-rimmed spectacles, crown. They have the look of big policy decision-makers anywhere—party leaders at a political convention, international dignitaries at the United Nations, or directors of a major corporation. Dr. Capoulosse

BABAR'S FAIR (1954)
Council of the Ministers (study)
Gouache and ink, 22 × 24 cm (8½ × 9½″)

BABAR'S FAIR (1954)
Celesteville with the Announcement for the Fair (study)
Watercolor, gouache, and ink, 31 × 52 cm (12 × 20½″)

BABAR'S FAIR (1954)

Arrival on the Celesteville Bridge (study)

Watercolor on black-line proof, 31.5 × 53.5 cm (13⅝ × 21″)

BABAR'S FAIR (1954)

The Celesteville Bridge at Night

Gouache, watercolor, and ink, 34 × 54 cm (13½ × 21½″)

Overleaf:
BABAR AND THE PROFESSOR (1956)
"The searchlights illuminated the cave."
Pen and watercolor, 37.5 × 54.5 cm (14¾ × 21½")

looks as if he is about to fall out of his chair in a stupor. General Cornelius appears the oldest and wisest, thanks to his spectacles and wrinkles. Babar is the active one: his crown suggesting power, his hands and trunk in positions of action. Podular, the sculptor, looks slightly lower-echelon compared to the others, because of the angle of his head and the way he sits at the table. They are similar to all such groups, and although they are in the process of planning a major exposition to celebrate the anniversary of the founding of Celesteville, they also look a bit like characters at a poker game. That resemblance of dignitaries at council to players in a game has its profundity.

Animals of all types will come to Babar's fair from near and far. The idea coincided with Laurent's interest at the time in the Movement de la Paix; when the assorted animal species join together in grand group compositions, they have the camaraderie and sense of shared purpose essential to a successful international meeting. There is a radiant concord in the scene showing the various attendees of the fair arriving on the great Celesteville bridge. The painting is a tribute to the contemporary developments of its time: aesthetically, politically, and scientifically. The animals' expressions of faith and optimism reflect Laurent's dreams for the peace movement; the sweeping suspension bridge extols recent progress in engineering. Laurent had driven over the pioneering Pont de Tancarville that had just been built near Le Havre and was deeply impressed. But—as in Jean de Brunhoff's books—elements of everyday reality are combined with outlandish fantasy. Beyond a bridge that truly exists in Normandy lies a lush tropical harbor, across it strides a Noah's ark cast of characters. Pages of clever details from the fair follow. Elephants and hippos use extraordinary snorkling equipment for an underwater excursion; it seems that there is no place that Laurent de Brunhoff could not imagine visiting or which he couldn't find the necessary means for reaching.

When this upbeat saga draws to a close, it is with a rich image of the bridge at night. Looking at the preliminary watercolor for it, you can breathe in the air of the harbor. You want to be right there, standing alongside the giraffes, dromedaries, hippos, and elephants. The sight of these animals standing placidly on a suspension bridge, looking at a *fête de nuit* in an exquisite make-believe setting, is riveting. As with the arrival scene, the familiarity of part of the subject matter makes the fantastic elements plausible; the bridge and starlit night are so credible that we could believe almost anything that occurs in their presence. The deep colors against the rich grays make this scene the most poignant sort of nocturne. Large, bold forms link the myriad smaller ones. To achieve this poetic vision Laurent first painted the water in watercolor, and then used a light gouache over it for the sky, stars, and other details.

Jean de Brunhoff had ended *The Story of Babar* with a touching and effective night scene, printed simply in black and white. For Laurent, night and darkness have figured even larger in major compositions in which the blacks are played against a panoply of other colors. *Babar's Cousin* ends with an atmospheric candlelit scene in Arthur's bedroom. *Bird Island* has the dinner under the lanterns.

BABAR AND THE PROFESSOR (1956)
"They glided through the gloomy arches."
Pen and watercolor, 39 × 56 cm (15½ × 22″)
Collection Phyllis Rose

In the books following *The Fair,* darkness and its illumination would continue to appear frequently. Laurent developed a sort of specialty of caves and underground passageways as well as of evening itself: the deep grottoes of *Babar and the Professor,* the midnight sojourn in *Babar's Castle,* the dramatic lighthouse rescue scenes at the end of *Babar's Mystery.* He renders both the romance and the anxieties of darkness and its conquest. One of his early artistic passions was for El Greco's night view *Toledo.* He feels that darkness "expresses a certain nervousness and fear—perhaps not really fear so much as tension. There is some sort of contradiction between the dramatic background and then the elephants, who are so placid. . . . The dark places may be dramatic passages, but on the other hand I would like to know them." That darkness may suggest the unknown and indecipherable, or it can be read as enclosure and security; both appeal. Laurent de Brunhoff thrives on the illumination of the unfathomable.

In 1954 Laurent and his family, which now included a six-month-old son, Antoine, moved back to Paris to an apartment on the Boulevard St. Germain in the Latin Quarter. In a studio on the floor above, Laurent created, in the course of the next thirty years, twenty-three Babar books (counting three small four-volume sets as single books), and nine books on other subjects. It was a well-organized life dedicated to the achievement of his work and the acts of living that fueled that work: a stroll to Nôtre

Dame or the Luxembourg Gardens, meetings with publishers or printers, time to read Flaubert, Stendhal, or Zola. In time Laurent and Marie-Claude also acquired a second home by the salt marshes and dunes of the Île de Ré on the Atlantic coast. This provided further opportunity for Laurent to study nature, perfect his skills as a gardener, indulge his passion for bird-watching, or simply stare at the water: to absorb himself in the pleasures of earthly existence that were both the nourishment and goal of his work.

The de Brunhoffs traveled as well. For the summer of 1954 they rented a house in St. Tropez. Laurent wrote *Babar and the Professor* there (although it was not published as a book until two years later). *Professor* appeared first in the magazine *Elle*—with both full-color and two-color plates—just as Jean de Brunhoff's *Babar and His Children* and *Babar and Father Christmas* were first published in the *Daily Sketch*. It introduces some colorful new characters—Professor Grifaton, who is the Old Lady's brother, and his grandchildren (based on Laurent's own Anne and Antoine)—with whom Babar and his family explore some fantastic caves. As a child Laurent had been both terrified and fascinated by the cellars at Chessy, which he could visit only when accompanied by an adult; now he invented some underground spaces of even greater drama. He lights those caves splendidly with lanterns on inflatable rafts and searchlights on speedboats. The straight white rays screeching from those searchlights are a great technical feat achieved with a nearly dry brush. If Jean de Brunhoff's nocturnal scenes were gently enveloping, Laurent's darknesses suggest discomfiting journeys of the unconscious mind. While he discarded Surrealist painting technique, he shared aspects of the Surrealist desire to stretch awareness and show some of the frightening sides of fantasy.

Laurent de Brunhoff's next book after *Professor* was his first outside the Babar series. He sees it as a break toward personal independence, proof that Babar had become such an irrefutable part of him that he was now free to break away toward "further identity of my own." Called *À Tue-Tête* (*At the Top of One's Voice*), the book was published in 1957 by René Julliard, with a text by Jacques Lanzmann and black-and-white illustrations by Laurent. Laurent's drawings are among his finest achievements. His socialites and diplomats are at times birdlike, elsewhere part ram, part rhino, part giraffe, part mule, or a blend of those species. Here animal qualities are the substance of caricature, and these grotesques resemble people we all know, seen cynically. A step away from the Babar world and working for an exclusively adult audience, Laurent has let loose with a new bite to his imagery.

À TUE-TÊTE (1957)
Rhino
Pen and ink, 65 × 50 cm (25½ × 19¾″)

À TUE-TÊTE (1957): p. 13
Pen and ink, 65 × 50 cm (25½ × 19¾")

There is a new dash to his line as well. In a drawing of a woman knitting, the explosive knitting needles at first look as if they have been placed randomly, but they have in fact been positioned meticulously to convey frenzy in as ordered a way as possible. Laurent brings something sinister, almost fanatical, to the act of knitting. The woman becomes a contemporary version of one of *les tricoteuses* of the Revolution watching the guillotine. By parodying little old ladies working away on their shawls and cardigans with this gawking creature in her spike heels, he makes the type even more fierce than Dickens's Mme Defarge. An allegedly harmless pursuit looks anything but.

The parodic *À Tue-Tête* points to another of Laurent's heroes: Goya. Part of what he cherishes in Goya is "the delectation and the pleasure of painting," but he also admires the candid grappling with evil.

"Goya, when he was becoming old and deaf, assaulted the horrors that were getting to him. He expressed this in his engravings about war and dreams and fear and terror. "*À Tue-Tête* is a diatribe on corruption, vanity, and pretention. The stylishness that is amusing in his father's books here becomes decadence. Jean de Brunhoff rendered evil above all as something to be defeated, as a foil for goodness. While vices never actually win out in Laurent's work, malevolence is more central to it, especially in his work outside of the Babar series. *À Tue-Tête* is downright cynical. *One Pig with Horns* of 1979 concerns vanity, anger, and egoism. *Bonhomme* of 1965 addresses our desire to capture and gratuitously imprison others, along with the issues of male potency and restlessness. While none of Laurent de Brunhoff's books toy with the possibility of an unhappy ending, they do not shirk the undercurrents of life.

À Tue-Tête (1957): p. 40
Pen and ink, 24.3 × 30.3 cm (9½ × 12″)

À TUE-TÊTE (1957)
The Piano Player
Pen and ink, 46 × 32.5 cm (18 × 12¾″)

In the early 1960s, Laurent published Babar and non-Babar books at a rapid pace. Outside of the series there were *Serafina the Giraffe* (1961), *Serafina's Lucky Find* (1962), *Captain Serafina* (1963), and *Anatole and His Donkey* (1963.) The *Serafina* books have a quite different look to them from the Babar series. The illustrations are more compact and simplified. The characters—in addition to giraffes these include Hugo the kangaroo, Beryl the frog, Ernest the crocodile, and Patrick the rabbit—are more human-looking than the inhabitants of Celesteville. Unlike Babar and his cohorts, they seem above all to be caricatures; although not as extreme or unclassifiable as the creatures in *A Tue-Tête*, they are, to a degree, in the same vein. Setting about their adventures (planning a birthday party for Serafina's grandmother, fixing up an old boat and trying to sail it, taking the boat out to sea), they resemble different species of human children more than different species of animals. *Anatole and His Donkey,* printed only in two colors, has a human being as its main character; he and his animal friends all register their sentiments so similarly that the emotional distinction between man and beast becomes virtually nil.

Babar's Castle of 1961 takes the family to Castle Bonnetrompe, which has, naturally, in addition to all of the usual castle amenities an underground passageway. It is a pleasant ambling into new territory. One wonderful picture shows the crowned Babar riding a tractor lawnmower called "La Merveilleuse." There is a splendid ballroom scene in which the Old Lady, in one of her most Cécile de Brunhoff–like poses, plays the piano as ecstatic elephants dance and are offered pink champagne, eclairs, fruit tartlets, and that great Babar favorite, croquembouche. It was the last of the de Brunhoff books to be published initially by Hachette. The Babar series had run on slightly hard times. By the late 1950s, Laurent had gotten to the point of having to do drawings for advertising and other "unexciting things" to support his family. With *Babar's Castle,* his publisher reduced the format of the books. Citing economic constraints as the reason, they cut the number of pages from the usual forty to thirty-two and the overall size to 12¼ × 8¾″.

In 1962 Laurent met Robert Bernstein, president of Random House, the publisher of the American translations of the Babar series ever since the 1930s. Bernstein asked him to do three new titles, after which Random House became Laurent's primary publisher. Laurent has been with Random House ever since, with Hachette continuing to publish the French editions of these books that now originate in America.

With the change came a working method that Laurent would use for the next twenty years. Returning to the technique Jean de Brunhoff had used for *The Story of Babar* and *The Travels of Babar,* Laurent abandoned the black-line proofs. His method was to start with sketches, in ink or pencil or both. Then he progressed to the storyboard, where he worked out the specifics of the plot. After that came further sketches, very close to the final state, followed by the actual art with the black

À TUE-TÊTE (1957): p. 26
Pen and ink, 44 × 32.5 cm (17⅜ × 12¾″)

BABAR'S CASTLE (1961)
The Banquet
Watercolor, gouache, and ink, 29 × 50 cm (11½ × 19½")

lines and colors on a single sheet ready to be reproduced. The system served him well until the early 1980s.

Laurent's first book for Random House was *Babar's French Lessons*. Published in 1963, it is a useful teaching tool; key words and phrases are printed in bold-face type, blue for French and black for English. Babar teaches the new language by chatting intimately with his readers. There is something far more sympathetic and amusing about learning from a charming old friend than a run-of-the-mill instructor. For one thing, Babar makes errors and corrects himself: "My nose is *mon nez*. I mean my trunk is *ma trompe*." In addition, he is far more personal than the average scholar in what he reveals of himself; in his very first lesson he discusses his feelings about his clothes, explaining that his green suit is his favorite, and in Lesson 2 he describes details of his shower. All of this is well illustrated. In Lesson 3 he takes you to a family breakfast, where his cousin Arthur puts four pieces of sugar into his hot chocolate, and everyone gorges on croissants with butter and honey and jam. When the Old Lady bakes "un gâteau au chocolat," a real recipe is printed. On a trip to the seaside you learn the words for swimming, fishing, and building a sand castle; you say a final "Bonne nuit" in the opulent royal bedroom. If the best way of teaching the French language is through exposing students to some of the glories of French civilization, Laurent de Brunhoff has put his concise vocabulary lessons in effective form. This is a course of instruction that any child, and most adults, would be eager to stick with.

BABAR'S CASTLE (1961)
Babar on the Tractor Mower
Watercolor, gouache, and ink, 29 × 50 cm (11½ × 19½″)

BABAR COMES TO AMERICA (1965)
"On the streets of New York, everyone seemed to be in a hurry."
Pen and watercolor, 29 × 40.5 cm (11½ × 16″)

In 1965 Random House published *Babar Comes to America.* Based on the trip Laurent and Marie-Claude de Brunhoff made at the invitation of Robert and Helen Bernstein, it is sixty-four pages, the longest of any Babar book. *America* is an authentic account of a foreigner's first impressions of the United States, more a straightforward journal than a tale with an elaborate plot. It focuses less on tourist attractions than on the nitty-gritty realities of travel, the sort of events generally kept out of travel literature but essential to the experience. This sometimes includes the annoyances as well as the numerous pleasures. In New York Babar gets something in his eye, is blasted by a bus driver for using the wrong change, and arrives at the site of a recommended store only to find a new skyscraper there. He manifests the slightly grumpy side of his personality along the way—complaining that his ears hurt in an elevator and that the street noise is too loud. For travelers willing to acknowledge the irritations and frustrations that accompany the thrills of a major journey, he is easy to identify with. What makes Babar's reactions universal is that everyday experiences move him more than the sights listed in guidebooks. He becomes absorbed by baseball games, the supermarket, factories, a barbecue, superhighways, a drive-in movie. In its keen-eyed response to neon, highway-strip America, and in its appreciation of commercial culture, it is akin to both Pop Art and Postmodernist architecture although its tone is far more mellow.

Observant and witty as Laurent had been with the imaginary situations of his preceding books, he thrived on a new reality. The watercolors of Babar's arrival at Dulles Airport, his press conference (at which he says how happy he is to be in the country "of Washington, of Mark Twain, of Danny Kaye"), his dinner at the White House, and outings in New York, all evoke familiar territory with great authority and grace. Babar is even more comic in the everyday settings featured in this book than in the make-believe locales of some of the other volumes. He is a great sight at a drugstore lunch counter where he straddles two stools, and inside a New York phone booth (from which he calls the Bernsteins, whose first names are used). His presence gives those locales magical charm. To see Babar participate in everyday life in Scarsdale—baseball, the supermarket, TV—is to enjoy such ordinary experiences in a fresh way. Of course, Babar gets the royal treatment throughout his tour: not just an audience with the president, but also the awarding of a doctorate from Harvard and a special tour of an automobile factory in Detroit.

Babar fishes in Lake Michigan, grills a juicy steak nearby, and zooms on a train through the Rockies to San Francisco. En route to Los Angeles he visits the beach at Carmel, Yosemite Park, and Death Valley. Looking through his eyes at freeways, a Beverly Hills swimming pool, and Disneyland, it is as if we are viewing them for the first time, too. When Babar, Celeste, and Arthur fill almost every cubic inch

BABAR COMES TO AMERICA (1965)
Drive-in Movie
Ink and watercolor, 19.3 × 18 cm (7⅝ × 7¼")

BABAR COMES TO AMERICA (1965)
Helicopter over Los Angeles
Ink and watercolor, 26.5 × 44.5 cm (10½ × 17½″)

BABAR COMES TO AMERICA (1965)
Celeste Buying Herself a Fur Hat
Ink and watercolor, 12.3 × 18.6 cm (4⅞ × 7⅜″)

of a car at a drive-in movie, we can practically taste the popcorn and hear the piped-in sound. This is really America: a landscape of automobiles, an oversized movie screen on which the projected giant faces seem as real as the life-size heads in the cars, and looming mountains that are part of the actual scenery but resemble a film set as much as the real world. De Brunhoff's imagery exceeds mere illustration. Through its shrewd details and deft style, it becomes commentary: on how people spend their time, on artifice, on the effects of mechanization on perception.

Babar and Arthur leave Los Angeles by helicopter—"each in his own, because together they would be too heavy for one"—in a spectacular two-page spread. As in his father's first two-page scene in *The Travels of Babar*, Laurent conveys a sweeping panorama with all the defining factors of the landscape—not just the topography and the architecture, but also the light, the atmosphere, and even the temperature. Babar regards the California city from an angle similar to the one from which he viewed the Mediterranean from a balloon over thirty years earlier (but at the same age). As in Jean de Brunhoff's books, objects look humorous and slightly animal-like; the wheels of the helicopter and Babar's headphones oddly resemble mechanical feet and ears. But both the content and the painting technique are now more streamlined. Laurent cuts into his subject matter as precisely and skillfully as those helicopter blades push aside air. An artist of uncanny sharpness, he knows what a place is all about. He doesn't linger over nuances as his father did—there are no little vignettes of everyday life to be seen on the street corners down below—but he really gets the look of Los Angeles, and moves through the distances and atmosphere flawlessly.

After California, Babar and Arthur view the Grand Canyon. They go down the Colorado River and meet Indians. They visit a ranch in Texas, the French Quarter in New Orleans, and a Yale-Harvard football game in which Arthur gets to play for a few minutes. The elephants celebrate Thanksgiving at the Bernsteins, where Babar holds a knife in his trunk to carve the turkey. Then, just before leaving the United States, Celeste stops to buy a hat in New York. She admires herself in a shop mirror that is almost exactly like the one before which Babar, clothed for the first time, preened in the original *Story of Babar*. In the farewell scene in which Babar's ship sets out from the tip of Manhattan, Laurent does not provide the details his father would have shown—the passenger's clothing and so on—but he makes a light and airy image. This graceful painting is a fine conclusion to this book in which—in the classic Jean de Brunhoff tradition—so many of life's pleasures have been enumerated.

In 1965 Laurent also wrote *Bonhomme*, another of his books outside the Babar series. Like *Anatole*, it is printed in only two colors, so the power of its illustrations depends above all on facial expression. Called a "little man," but not really resembling one, the odd creature named Bonhomme is drawn in the most abbreviated manner possible—one line for his mouth, dots for his eyes, no nose or ears, and a spikelike form growing out of the back of his head—but he expresses pensiveness, eagerness, curiosity, humor, terror, and bliss. As in *À Tue-Tête*, and even more strongly than in his Babar books, Laurent focuses on character and emotions. He handles settings and other details adeptly—his pen-and-brush renderings of the tree under which Bonhomme often sits are magnificent—but he keeps their role secondary. *Bonhomme* is packed with psychological innuendo. The book is about freedom versus constraints, and the phallic spike a central issue.[3] A little girl named Émilie discovers him and

BONHOMME (1965)
Bonhomme in Front of the Mirror
from the printed book

BONHOMME (1965)
Bonhomme Leaving
from the printed book

BONHOMME (1965)
Bonhomme Running around the Tree
from the printed book

BABAR COMES TO AMERICA (1965)
Farewell to New York
Ink and watercolor, 30.6 × 48 cm (12⅛ × 18⅞")

doesn't return home, so the police search for her. When they find her they catch Bonhomme in a net and lock him up in a zoo, where his spike begins to wilt. Émilie implores the mayor to free her little friend; the mayor agrees under the condition that Bonhomme "put a cork on the end of his spike." Allegedly free, he then must have the ridiculous cork—always orange when the rest of him is in black and white. Émilie's father offers Bonhomme some equally phallic-looking cigars. "That is what Bonhomme likes best. He smokes two at a time." Fortunately, Bonhomme soon escapes this normal human world. He leaves his cork behind and goes back to his mountain, where Émilie often visits him and from which she always returns "with a funny little face."

The tale is in ways a precise reversal of *The Story of Babar.* Village life has nothing good to offer; civilization is best avoided. Confinement—not just in an obvious form like a cage at the zoo, but also inside a nice bourgeois house—means emasculation. Bonhomme thrives on the mountain. His spike is in good order there, and that is where it is rewarding for Émilie to follow him. Restlessness and intensity—apparent in the visual elements of Laurent de Brunhoff's books from the start—here dominate the story line as well. In *Bonhomme and the Huge Beast,* published nine years later, Bonhomme ties his spike in a knot when he is angry at Émilie, and it curls up when he is sad. But this second book is in general more of a typical de Brunhoff adventure story—printed in full color—in which Bonhomme and Émilie encounter a huge beast and other animal characters.

ONE PIG WITH HORNS (1979)
"Pig hates his head. . . ."
Ink, 22 × 21.5 cm (8¾ × 8½")

ONE PIG WITH HORNS (1979)
Pig Gets Mad
Watercolor, 22.5 × 21.5 cm (8¾ × 8½")

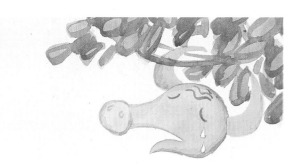

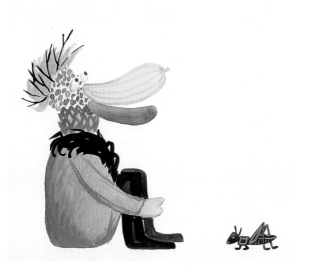

ONE PIG WITH HORNS (1979)
"How is all this going to end?"
Watercolor and gouache, 30 × 21.5 cm (11½ × 8½")

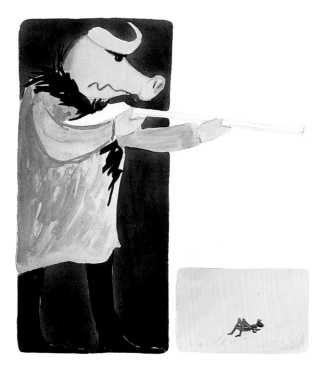

ONE PIG WITH HORNS (1979)
"I hate you all."
Watercolor, 24 × 21.5 cm (9½ × 8½")

Laurent's other non-Babar books have been *Gregory and Lady Turtle,* published in 1971, and *One Pig with Horns* of 1979. In *One Pig* as in *Bonhomme,* freedom from Babar invited new expressiveness. The central figure is an angry, envious, egomaniacal pig whose life takes a desperate course. He puts on horns to be as handsome and temperamental as a bull. He hates all other animals because of what they have that he lacks (cows their horns, sheep their wool). He tries to be a clown but is outraged when his jokes fail. He becomes a woman, but after a bad dream wakes up having forgotten who he is and wants to be a baby instead. Then as an infant he roars with anger, and so, deciding he must calm down, he becomes a flower. He continues to battle left and right with various identities, at last turning into a creature with a face made of vegetables. Finally, however, he ends up as himself again, happy and content—his only variation from his original form being that he has retained one horn with which to make music.

The book is a provocative existential parable. In a disarmingly candid way it presents rage, willfulness, and above all the wish to be something other than what one is. Like *Bonhomme,* it deals with a particularly male variety of the drive toward independence; even if the pig ends up reconciled to being the creature he started out as, he still keeps a horn. Energy pulses here; reading this volume isn't unlike being catapulted through a synopsis of someone's psychoanalysis. The painting is vivid and haunting. The imagery is at times brutal, the colors startling. At a further remove from the world of his father, Laurent de Brunhoff expressed himself even more dramatically and pointedly than usual.

ONE PIG WITH HORNS (1979)
"Ridiculous?? Me?"
Ink, 22 × 19 cm (8½ × 7½″)

Laurent de Brunhoff has been publishing Babar books with Random House, generally at the rate of one a year, since 1965. One of the most inventive is *Birthday Surprise.* Its plot revolves around Celeste's idea that Podular the sculptor carve a giant statue of Babar in the side of a mountain, like the presidents at Mount Rushmore, as a surprise for his birthday. Everyone is anxious that Babar not even glimpse the great monument until the actual day. When Babar and Celeste are out on a walk, she becomes "nervous because Babar is so deep in thought." She is afraid that he suspects something, but the problem is that he is upset about having lost his pipe on a fishing expedition a few days earlier. We hear quite a bit about this pipe. A marabou cracks it; Babar plans to glue it together; Celeste says she will give him a beautiful new one.

Crisis in Celesteville is a missing pipe, or someone who might see his birthday present ahead of time. The danger level has gone down since the Old Lady's snakebite and the fire at Cornelius's house in *Babar the King.* Under Laurent's auspices, the worst sort of occurrence consists of a character getting temporarily lost or slightly injured. Arthur, for example, hurts himself in *Birthday Surprise* when his wild jumping causes the scaffolding around the statue to collapse. But the wound is easily treated with Mercurochrome and a long and hilarious bandage wrapped around his trunk. The dressing makes his voice sound "funny," but there are no worse consequences. Above all, life is a series of joys. The

mountain-size statue of a standing elephant wearing a bow tie, waistcoat, and crown is concealed by a thick flock of multicolored birds that resemble living confetti. When the statue is revealed, a marching band plays a trumpet fanfare. Everyone enjoys the birthday. And, of course, there is a delicious birthday cake. In this case the confection illustrated is a spectacular creation that is a cross between a giant baba-au-rhum and a croquembouche. No mere frosted sheet cake would possibly do for a royal family so deeply rooted in French culture.

It takes a bit of an ego to be thrilled with a giant statue of oneself carved into a mountain. But then again Babar has never minded the prerogatives of kingship. When Jean de Brunhoff had him jump into the water to save Alexander from a crocodile in *Babar and His Children,* he may not have seemed to care when his crown fell off and sank to the bottom of the river, but one page later he hired a duck to retrieve it for him. This frank relish of his royal status may be a big part of Babar's general appeal. Lots of people might enjoy seeing mountain-size statues of themselves; they just wouldn't dare say so. The falseness that underlies much modesty is something from which Babar does not suffer.

Babar Visits Another Planet is one of Laurent's most successful forays into the unknown. When Babar, Celeste, and the rest of the clan head into outer space, their rocket doesn't just go to an ordinary spot like the moon or Mars; they land rather on a more distant planet that isn't even on the charts. The nature of the plot is familiar—adventure, catastrophe, rescue—but the details are new. The planet offers a series of unprecedented experiences: soft, caramel-like ground; bizarre-looking inhabitants who travel in skimmercraft and flying eggs; a breakfast fountain that automatically spits out cakes and soft drinks; and a city hanging from enormous balloons. Yet one of the great features of these books is that for all the innovations each one offers, certain familiar touches reappear almost as faithfully as some of the characters; balloons, suitably buoyant and playful, are among those staples.

In *Babar and the Wully-Wully,* de Brunhoff comes up with another imaginary species. The wully-wully is a furry little animal who eats and sleeps hanging by his tail and is so alluring that elephants and rhinos, who keep him on a leash, are prepared to do battle over him. Eventually, he functions as an ambassador of peace between the two rival species.

In the scene showing the abduction of the wully-wully, the caricature has the same edge to it as the drawings in *À Tue-Tête.* It is a tough, cynical image: intentionally disruptive, its powerful rhythm established with deliberately thin paint coverage. Another illustration shows Arthur disguised as a hat merchant going to the land of the rhinos to rescue the splendid little character. Laurent de Brunhoff is the master of sinister characters; his gangsterish rhinos, whose facial expressions range from demonic to simply stupid, make for hilarious viewing. In their midst, Arthur makes a wonderful buffoon, Zephir the consummate image of angelic good nature, and the wully-wully itself an appealing, saintly enigma. The scene is enriched by terrific clothing, unusual Maya-influenced architecture, the unique hat-sellers' vehicle, and, in the midst of it all, that furry little hedgehog-like character. As magnetic as a religious cult figure or a major rock star, he has by this point in the story become the object of vast public obsession.

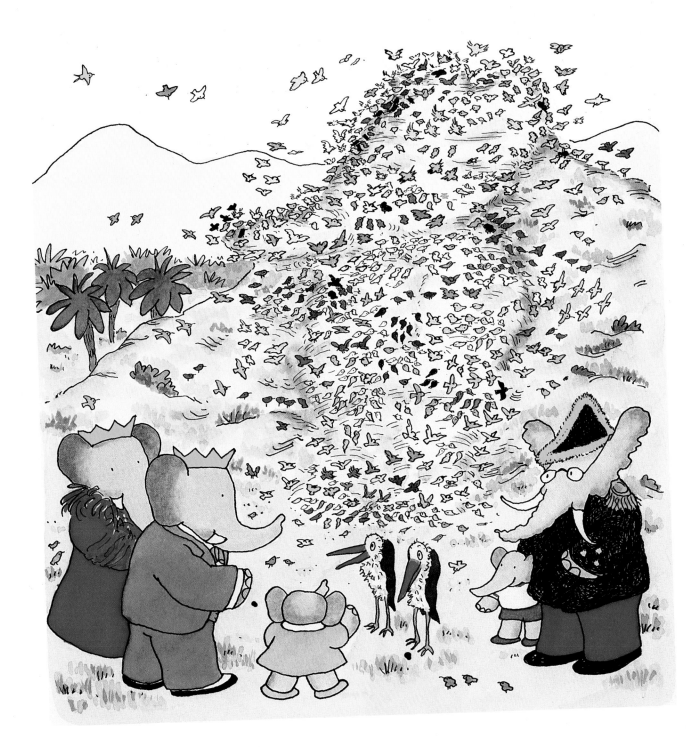

BABAR'S BIRTHDAY SURPRISE (1970)
Birds Covering the Mountain
Pen and watercolor, 21×18 cm (8¼×7″)

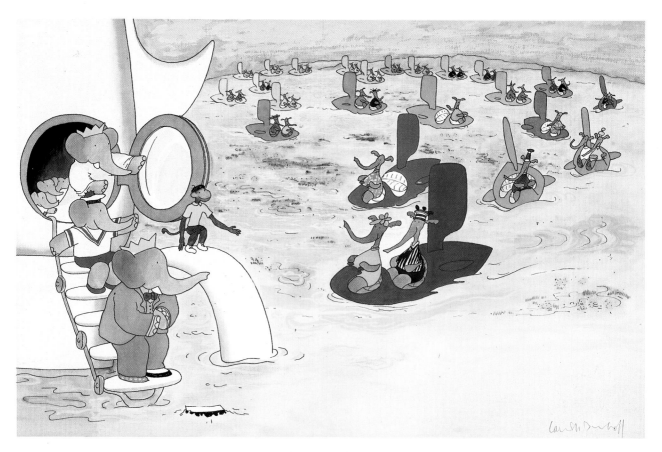

BABAR VISITS ANOTHER PLANET (1972)

"They looked like elephants, but yet they were not elephants."

Ink and watercolor, 32 × 50 cm (12¾ × 19¾″)

Collection Phyllis Rose

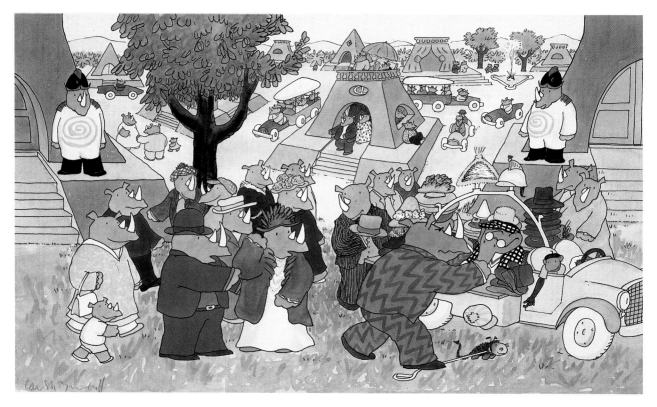

BABAR AND THE WULLY-WULLY (1975)

"A strange hat merchant arrived in the city of the rhinos."

Ink and watercolor, 32 × 50 cm (12⅝ × 19¾″)

Like *Bonhomme,* the *Wully-Wully* deals with freedom and captivity. Spunky little Flora is only able to persuade the fierce rhino Rataxes to free the wully-wully when she points out that when he was hers he stayed with her although she never tied him up or put him in a cage. Once the marvelous little creature is free, he is a true messiah. His impact on the brutal Rataxes is such that the rhino gives up his warrior costume for the attire of a retired gardener, which he wears while sitting on a riverbank and letting the wully-wully swing from a rope attached to his horn. This delightful illustration is the Babar version of the proverbial lion lying down next to the lamb.

In the early 1980s, with *Babar's Book of Color,* Laurent changed his working method. He began to watercolor on barely visible pencil lines and put the black line on separate transparent acetate overlays. That bold outline is necessary to the ultimate legibility of the finished piece, but sometimes it limits the artist's freedom. Laurent's battle is to keep the spontaneity in spite of that line, and to maintain the transparency that is basic in watercolor. He likes to capture the quality of air—more than the texture of the objects themselves—and transparency is essential to doing so. He wants atmosphere, which he considers mandatory to the look of fantasy. For that reason he doesn't like the heaviness of gouache. Lightness is one of Laurent de Brunhoff's imperatives. It is characteristic of much of his subject matter—birds, flying machines, even winged elephants—as well as of the appearance of his art.

What distinguishes the watercolors in his recent books is their lightness, delicacy, and touch. These are also the hallmarks of the paintings he has, for the past few years, again been doing outside of the Babar books. The no-holds-barred vision of *Bird Island* has given way to increased refinement and lightness of mood. The subtlety evokes subtle response. We notice quiet, details, the spaces between objects, the interstices in life.

Look at the harbor views and nighttime scenes around the lighthouse in *Babar's Mystery* of 1978 and you see the new delicacy of touch and pleasure in the medium. In the scene in which "the crocodiles stop in their tracks, flabbergasted," the different densities of water, rocks, and air are palpable. For the sky he crosshatched over a pale gray wash; for a distant mountain he intensified the same sort of crosshatching, working it into solid mass on top of darker gray. He left the water a simple light wash of grays and browns. Like his father a dramaturge of light and dark, Laurent uses the setting to create an atmosphere laden with excitement and adventure. From the lighthouse—based on a combination of the Phare des Baleines (Lighthouse of the Whales), on Île de Ré, and the lighthouse at Montauk on Long Island—a broad but well-confined beacon of light spreads itself across all the murkiness. And the foreground is illuminated—perhaps theoretically with moonlight, but as if by theater spots—to reveal a marvelous moment of storytelling. The sinister crocodiles, perfect gangsters in their loud clothes and

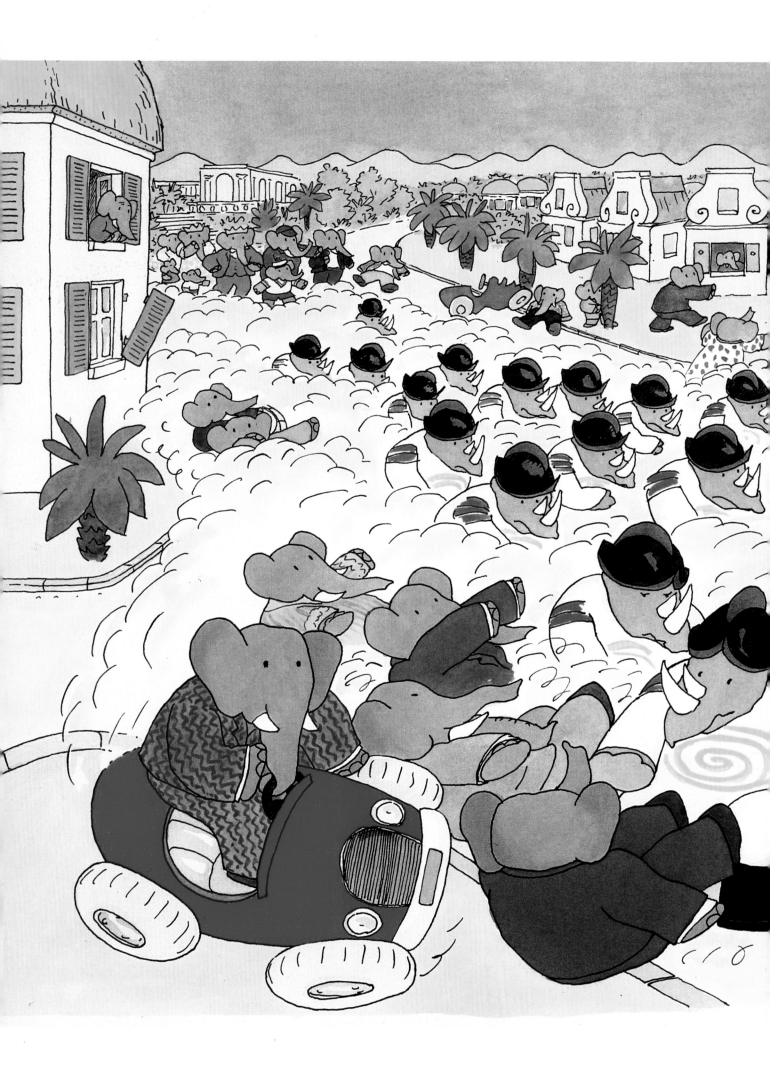

BABAR'S MYSTERY (1978)

"The crocodiles stopped in their tracks, flabbergasted."

Ink and watercolor, 26.3 × 45.6 cm (10⅜ × 18″)

BABAR'S MYSTERY (1978)
Lighthouse
Ink and watercolor, 20.3 × 18.7 cm (8 × 7⅜″)

white shoes, have just loaded a roadster, a piano, and other stolen loot onto a boat. They are halted in their tracks by that voice of reason and goodness: the Old Lady. At sea, also catching the light, is a motorboat with a wicked-looking bodyguard/henchman rhinoceros sitting in it. This creature may only be a minor detail, but Laurent has caught the posture of a thug perfectly. As for perky Babar and Arthur peering out from behind the base of the lighthouse: they are incipient salvation itself.

In 1980 Laurent de Brunhoff made *Babar's Little Library,* four tiny books—each measures 3⅝ × 2½ × ¼″—devoted to the elements of the universe. They are *Air, Earth, Water,* and *Fire.* "To me it was a sort of Zen meditation to contemplate the four elements and the universe. It was a kind of absolute, getting the essence of things in a whimsical way. If you look superficially at a sink with a faucet, it doesn't mean anything, but if you meditate, you imagine what this little bit of water means." These small books permitted the artist to eliminate background, an allowance he deemed a considerable luxury. Such focusing is the goal of much of Laurent de Brunhoff's life. He invariably does ten minutes of yoga every morning to lead him toward it. Concentration is what leads him toward the simplicity and evocation of absolutes his work achieves at its best.

Here scenes familiar from earlier books exemplify principles of life rather than illustrate plot. In *Air,* movement through air is demonstrated by birds of the type that veil the monumental sculpture in *Babar's Birthday Surprise,* then by ballooning as it occurred in Jean de Brunhoff's *Travels of Babar,* then by a small airplane with Arthur sitting in it as he did in *Babar's Cousin,* and then by a larger commercial plane of the type taken in *Babar Comes to America.* These variations on old themes put them in a new, profound context.

Drinking, showering, fishing, swimming, rain, and the sea are rendered as everyday miracles in *Water.* When Babar takes a shower his eyes are closed not just to keep out soap, but to express ecstasy. He looks thrilled not only at the sensuous experience of that rush of water, but also at the facts of liquidity, water pressure, gravity, hotness and coldness. Babar and Celeste watering their garden (she with a hose, he with his trunk) elevate an everyday activity to magic. Large issues are reduced to miniature scale in these volumes, which in a way is what the *Babar* volumes have always been about.

Nineteen eighty-one marked the fiftieth anniversary of *The Story of Babar.* The event was celebrated in both France and America. That summer, at a major exhibition at the Centre Culturel du Marais in Paris, visitors entered between the legs of an oversized cut-out of Babar and had the chance to see more than five hundred original paintings for the series, selected by Laurent and the director of the Marais, Maurice Guillaud. Guillaud was responsible for the dramatic installation that included a room-size balloon to separate Jean's and Laurent's work. Random House published *Babar's Anniversary Album,* which reproduced slightly abridged versions of three of Jean's and three of Laurent's books, along with an introduction by Maurice Sendak and a reproduction of the handwritten text of A. A. Milne's introduction to the English edition of *The Story of Babar.*

Following the exhibition at the Marais, the American-based International Exhibitions Foundation organized a major show called "Fifty Years of Babar." In 1983 and 1984, it traveled to the Minneapolis Institute of Arts; Meridian House International in Washington, D.C.; the San Diego Museum of Art; the

Wave Breaking (1981)
Watercolor, 38 × 57 cm (15 × 22½″)

San Jose Museum of Art; the Block Gallery at Northwestern University in Evanston, Illinois; the Cedar Rapids Museum of Art; the Baltimore Museum of Art; and the Toledo Museum of Art. Rarely had art intended primarily for children's books been shown in art museums. A public already in love with Babar came in hordes, and a whole new following emerged as well.

In the early 1980s Laurent de Brunhoff produced three books along the same lines as his father's original *The ABC of Babar*. These are *Babar's Book of Color, Babar's ABC,* and *Babar's Counting Book*. The use of a magician, a monkey, a mouse, and a merry-go-round to illustrate the letter *m;* pumpkins in various states of carving to demonstrate a vivid orange; and three motorcars to illustrate the number 3 is not unusual in the realm of children's instruction books. But what lends them character is the skill of the illustrations and the pleasure the subject matter brings to readers nurtured on over fifty years of Babar. Consider, for example, the page of four hippos. Each of these lumbering creatures has a different, highly effective expression on his face. The stream in which they immerse themselves is a splendid blue green. Perky Zephir—seated on the little ledge created by the numeral 4—and playful Alexander, who is running near some distant palms, are old friends whom we are happy to see again. The kitchen that illustrates *k* in *ABC* is no ordinary room. Rather it is a place where Babar and Celeste, dressed to the nines, come up with such tempting food that one of their children cannot keep his trunk out of a dish, and where an irresistible kangaroo, koala, and kissing kitten are also in attendance.

Waves on the Rocks (1987)
Watercolor, 38 × 57 cm (15 × 22½")

In 1985 Laurent de Brunhoff left France for America. Babar has flourished with the move. Since taking up residence in Middletown, Connecticut—at the edge of the campus of Wesleyan University, where he lives with writer Phyllis Rose—Laurent has produced two new books: *Babar's Little Girl* (1987) and *Babar's Little Circus Star* (1988). *Little Girl* gives Babar a new daughter, named Isabelle. In view of the recent events of his own life, it is fitting that de Brunhoff introduced a major change for Babar as well. *Little Circus Star,* part of a series called *Step into Reading,* is a smaller and minor, but highly charming, volume that takes Isabelle on further adventures, in language simple enough for first-graders to read.

His life in America gives energy to the work Laurent has taken up outside of the Babar series. Traveling to places like Martha's Vineyard and Hawaii, and simply looking out of the window of his house, he has been inspired to produce series of watercolors. Laurent used a Japanese brush for many of these. This enabled him either to work the paper very wet or to "use the brush almost dry, and just caress the paper." The attitude of this soft-spoken, reticent man toward both art and living emerges in those words "caress the paper." They characterize his gentle yet intense response to appearances and his wish to capture them in his art. The resultant paintings permit his virtuosity, his love of Oriental simplicity, and his sense of the utopia offered by the natural landscape to shine. They have the spontaneity that first took strong form in the watercolor studies for *Bird Island,* but they also have the new lightness. They reveal increased dexterity as well as the ability to make a final artwork that is tidy,

The Surf (I) (1987)
Watercolor, 49.5 × 38.5 cm (19½ × 15″)

The Surf (II) (1987)
Watercolor, 51 × 38.5 cm (20 × 15″)

The Sea at Night (1987)
Watercolor, 30 × 40.5 cm (11½ × 16″)

compact, and spare. They also betray the acuity with which Laurent observes his surroundings; he has the ability to look at waves breaking on the rocks, file the visual memory, and weeks later conjure it up with total recall.

Babar's Little Girl opens with the news that Celeste is going to have another baby. She has a lovely pregnancy in which she wears a flower-patterned maternity dress and rides in a pink carriage pulled by two smiling giraffes. But her labor is so sudden and quick that the baby is born even before Dr. Capoulosse can reach her.

The child, Isabelle, is a fiery charmer from that moment on. She eats a lot, walks early, blows a trumpet, and gets her brothers and sister to help roll over a hippo who is crushing a turtle. When she has a birthday party it is in the grand Babar family tradition. Naturally it is a sumptuous banquet. The musicians of the Royal Guard play, and the Old Lady caters. Everyone wears splendid costumes in vibrant colors that epitomize the festive spirit of the occasion.

As she gets older, Isabelle becomes a great spunky kid with a knack for getting into trouble. She is so excited to have new roller skates that she forgets to come home for dinner and gets scolded by Babar. The perfect inheritor of the family mentality, she sings loudly and skips and jumps with all her might. She is so sure of herself that she happily plays hide-and-seek by herself.

Not only is hide-and-seek the game that Laurent and Mathieu de Brunhoff often played in Chessy fifty-five years earlier, but it perfectly suits the nature of the Babar books. A universally favorite activity of children, hide-and-seek offers its participants rare suspense and power. For a few moments there is the marvelous satisfaction of feeling that you are completely on your own, that no one knows where you are. Yet there is also the certainty that you will be discovered. Almost every two-year-old plays the game in its most primitive form by covering his eyes while the grown-ups with him ask in dismay where the child is, often calling out his name as if in a desperate search. The child grins ecstatically while the others exclaim, "I don't know *where — —* is! Does anyone know where — — is?" Then, with a flourish, the child pulls his or her hands away, at which point everyone exclaims, "There — — is!" bestowing absolute bliss on the kid. It's a process of separation and reunion in its most reduced form. Connections are severed, then reestablished. The same theme is in many ways, on a larger scale, the essence of almost all of Jean and Laurent de Brunhoff's books, and to some degree of Laurent's own life.

After solo hide-and-seek, Isabelle pretends to be hitchhiking (the pretending having been, as already discussed, a compromise with the publisher). An odd diversion for a child, it perfectly suits her carefree temperament. Isabelle has the usual intrepidity of the Babar family. She belongs to the tradition of the great adventurers, among them Babar himself, Arthur, and Alexander. She does exactly what her parents tell her not to do. As fearless as the best of her kin, she soon enough finds her way to a place called the Blue Valley, and a good deal further out of reach than she might travel in any hide-and-seek game.

The house that Isabelle faces across the valley is a Greek Revival structure. The belvedere on the roof resembles the one in Chessy, but above all this is a New England house, based on sketches Laurent made of the Greek Revival house of the president of Wesleyan. "Nevertheless, the landscape in this book remains totally fantastic," according to Laurent, "especially the blue mountains shaped like mountains in China, where I've never been, except in my imagination."[4] It all adds up to Laurent de Brunhoff's personal utopia: first Chessy and more recently New England, as well as a land of clear water and bountiful nature—in this case palms, pines, and apple trees side by side. He has rendered his nirvana light and airy. The paint coverage—now thinner than ever before—creates an other-worldly atmosphere. On one level we have come a long way from *Bird Island;* the image now is as delicate as can be, the attitude a bit removed, the tone serene and even. But in the passion and profound Romanticism underlying the vision, things are very much the same.

Isabelle is a child of the eighties who uses a cassette player and earphones. Babar, however, still appears to be the same age he has been since 1931. Jean and Laurent de Brunhoff manipulate time as freely as they dress elephants in human clothing. Yet age does exist in these books. The elephant who drives Isabelle to the Blue Valley in a motorboat is so old that he "cannot see well anymore." Still, he

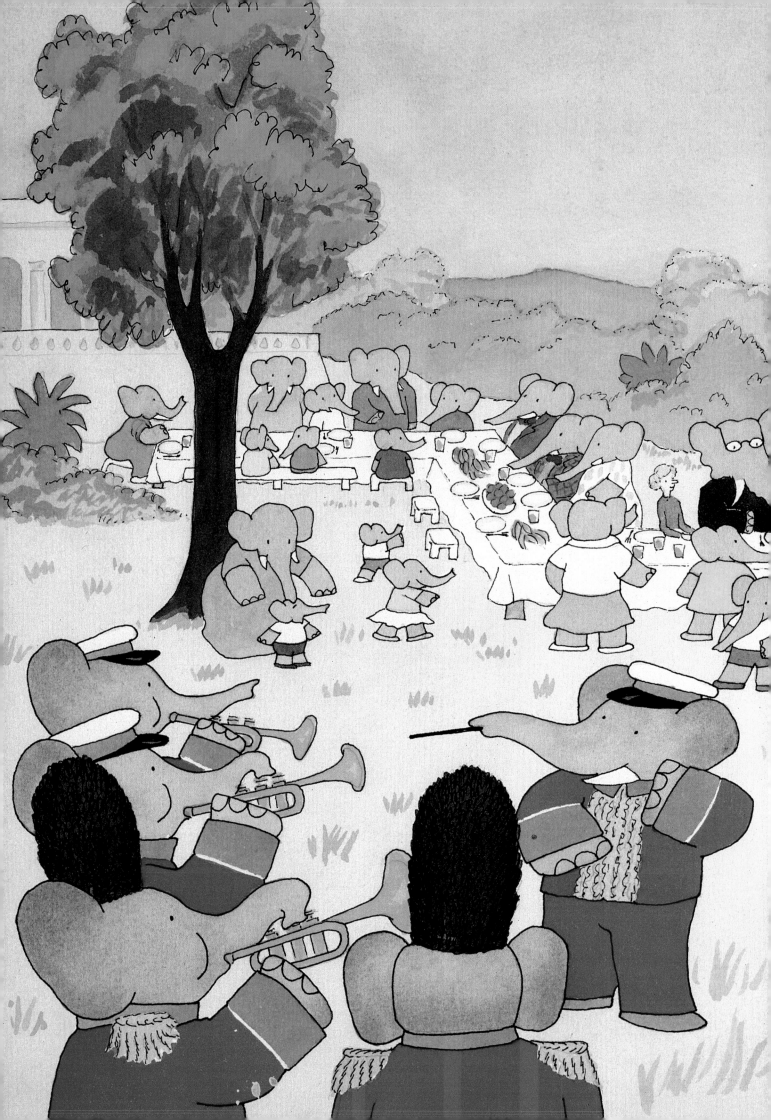

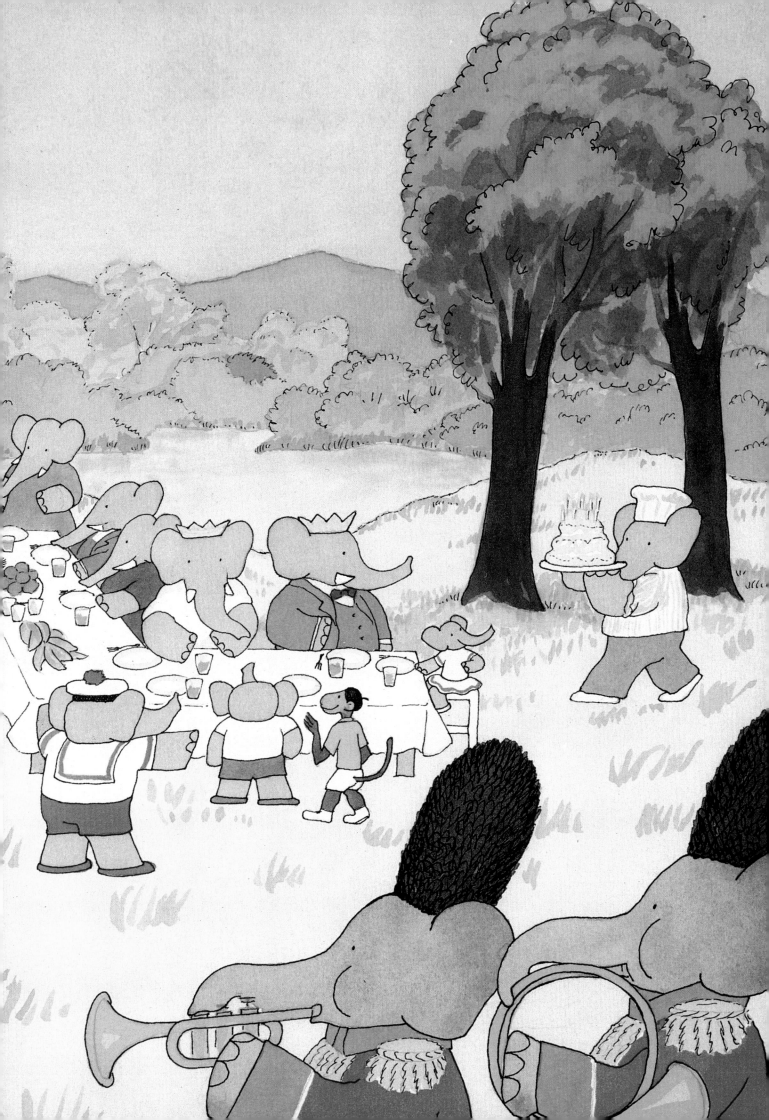

never misses the landing; age is accompanied by knowledge. This slightly decrepit character ends up precisely where he wants to end up. The wonderful picture of him motorboating Isabelle across a river illustrates questing youth guided by protective wisdom. The old elephant's hand on the throttle remains steady. He has certainty even in near-blindness—possibly as a result of the concentration it forces. Isabelle on the other hand is the essence of impetuousness, uncertain of where she is going but desperate to get there. She holds her trunk up in the air pointing forward towards the brave new world on the other side.

Isabelle meets up with a couple of characters named Boover and Picardee, who are closely related in appearance to the creatures in *À Tue-Tête*. They are loosely based on Bouvard and Pecuchet, the eccentrics who live together in the French countryside in Gustave Flaubert's last, unfinished novel.[6]

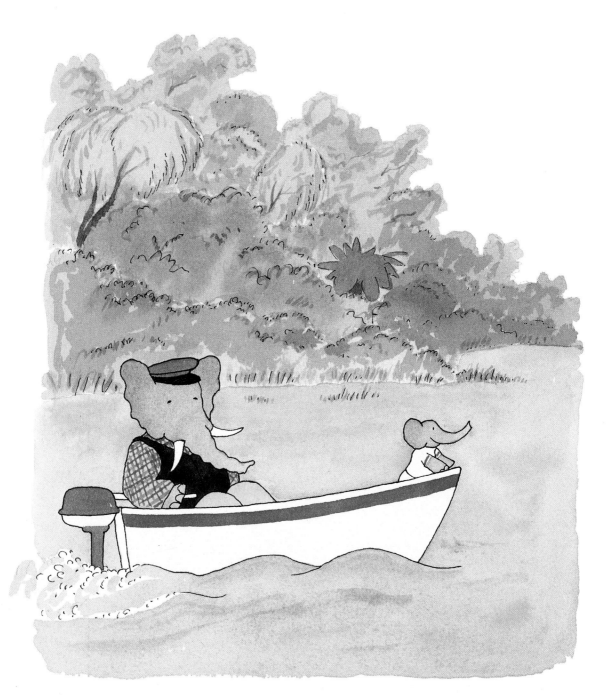

BABAR'S LITTLE GIRL (1987)
Isabelle in the Motorboat
Watercolor, 21 × 18 cm (8⅜ × 7¼")

BABAR'S LITTLE GIRL (1987)
The Blue Valley
Watercolor, 24.5 × 47 cm (9¾ × 18⅝″)

BABAR'S LITTLE GIRL (1987)
Flying on the Hang Gliders
Watercolor, 33.5 × 48 cm (13¼ × 19″)

They are a bit like Bonhomme—and perhaps like aspects of Laurent de Brunhoff's vision of himself—happy to be off in the wilds on their own rather than in the swing of things. Isabelle has a great time with them. She stands on her head, plays poker, beats the drums, and tap-dances. And then she learns that she must go home. From a giant television, in a wonderful sort of Romanesque grotto, her royal father beckons her. He is both Big Brother and, like fathers everywhere, the traditional figure of authority. Babar always knew how to project a strong image—consider Jean de Brunhoff's rendering of him at the photographer's in *The Story of Babar*—and now, with his trunk curved upward, he is imperiousness personified, or, rather, elephantized. The setting, too, dramatizes his august presence; if Babar can reach you in this majestic hideaway, he can reach you anywhere. It is a wonderful composition. The purples and blues of the domes lend romance and enclosure to another of Laurent's fine grottoes. The rich blues and grays subdue the atmosphere appropriately. The black adds drama and holds the space back. The broad strokes of muted watercolor establish the roundness and solidity of the columns. Consequently, we are riveted, as are the three listeners in the foreground.

Isabelle flies home on a hang glider. Her "heart was racing. She was flying like a bird." After all, her parents took their honeymoon, fifty years earlier, in a hot-air balloon. Her father took a horse-drawn sleigh to the mountains of Bohemia. Her brothers went to a distant island on the backs of giant birds. Even more recently, her father visited mysterious grottoes on an inflatable raft and outer space in a rocket ship and floating eggs. Why shouldn't she try a hang glider?

Clutching Picardee's shoulders with her trunk, she is the image of youth: intrepid but dependent, impetuous but somewhat terrified. As such she is a universal child, the sort of youngster who at one moment announces, "I want to do it *myself*," and without catching his or her breath adds, "Help me, mommy and daddy!" She may be an elephant in a dress, flying with an indescribable creature in an imaginary machine, but she is totally familiar. And she is in a world that, fictitious as its details are, is in some ways completely recognizable. We feel as if we can see and breathe the air, and our eyes move easily between the foreground and the distant setting, following the lines of the hazy purple mountains and fanciful architecture. The sky and the mauve mountains and rivers are a really wet, luminous watercolor. This is Laurent's new, lighter, brighter universe, where the buildings seem to frolic and the colors soar.

The adventurer ends up happily at home. The consequences of daring are never dire in the world of Babar. Risk makes life worth living, and brings little harm. Intrepidness always wins out. In Jean de Brunhoff's memorable *Babar's Dream,* courage and hope and perseverance were the angels—cowardice, discouragement, and fear among the ugliest demons. Faith and tenacity are what enable Babar, Zephir, Arthur, and Isabelle to plunge into the thick of experience.

You can solve problems, and you can do practically anything you want. This is clear not only in the stories, but in the style and form of these books. When exuberance is tempered by rationalism, possibilities abound. Grounded in solid technique, the de Brunhoffs celebrate both truth and fantasy. Laurent convinces us that Isabelle can push a hippopotamus off a turtle and that a part-Connecticut, part-Chessy house is really standing in front of mountains that belong in China, a place he has never been. It's the same ability that enabled his parents to put an elephant into clothing and savor the paradise that earthly living can be.

BABAR'S LITTLE GIRL (1987)
Babar Imploring Isabelle to Return
Watercolor, 21 × 19.6 cm (8⅜ × 7¾")

A Selection of Paintings

by Jean and Laurent de Brunhoff

All of the works reproduced are original watercolors or gouaches
unless marked by an asterisk, which indicates that they come from the printed books.
While some are illustrations in their preliminary stages, others are the
final versions that were sent to the printer.

Jean de Brunhoff

THE STORY OF BABAR

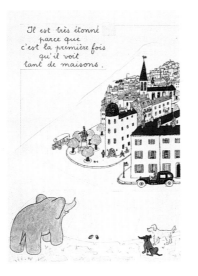

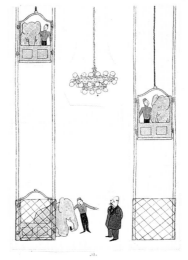

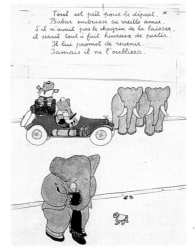

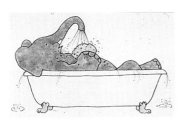

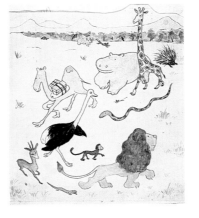

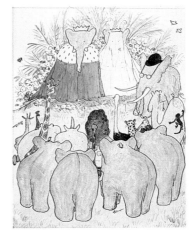

THE TRAVELS OF BABAR

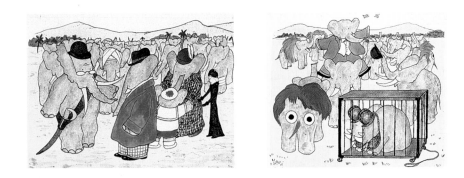

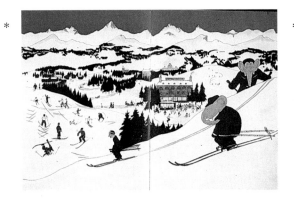

*

BABAR THE KING

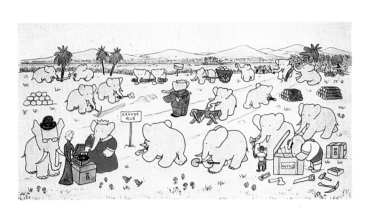

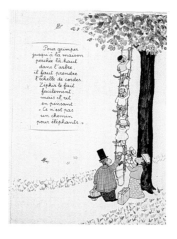

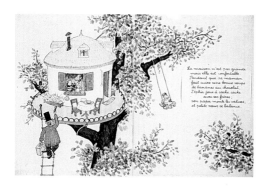

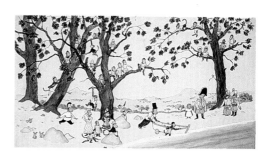

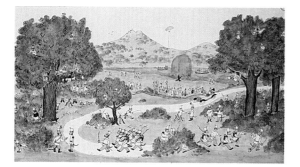

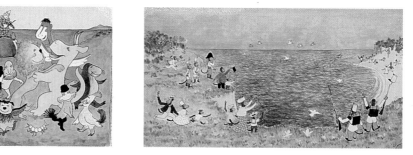

BABAR AND HIS CHILDREN

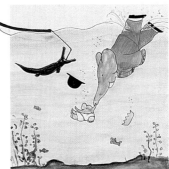

BABAR AND FATHER CHRISTMAS

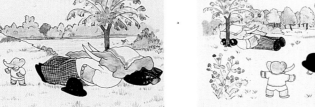

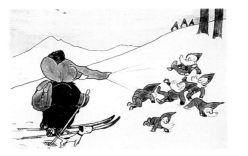

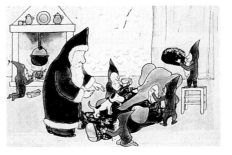

Laurent de Brunhoff

BABAR'S COUSIN: THAT RASCAL ARTHUR

BABAR'S VISIT TO BIRD ISLAND

BABAR'S PICNIC

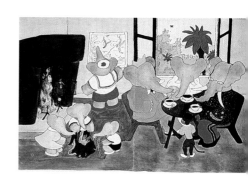

BABAR'S FAIR

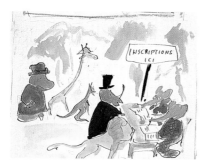

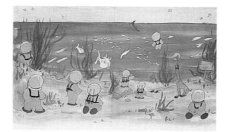

BABAR AND THE PROFESSOR

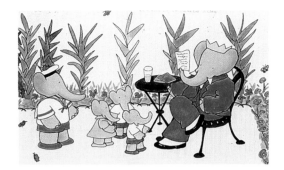

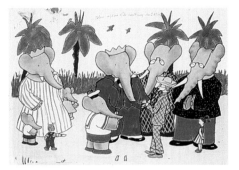

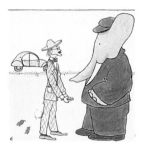

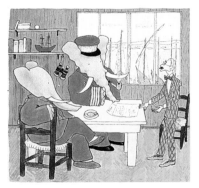

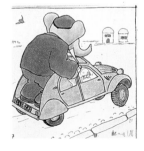

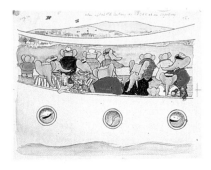

BABAR'S CASTLE

SERAFINA THE GIRAFFE

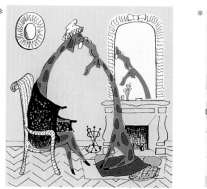

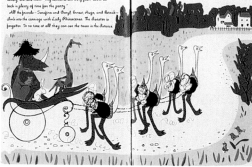

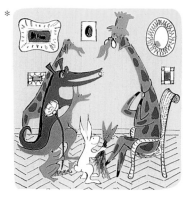

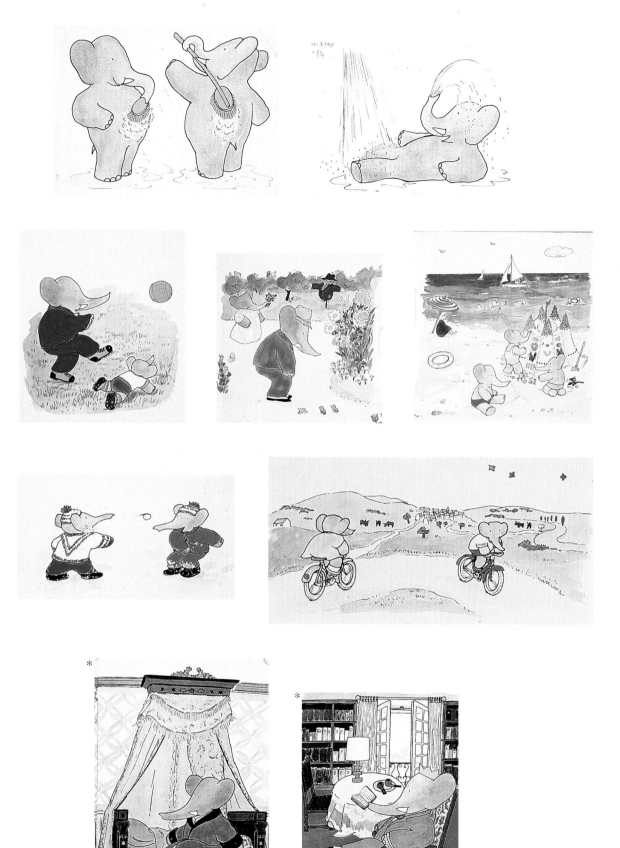

BABAR VISITS ANOTHER PLANET

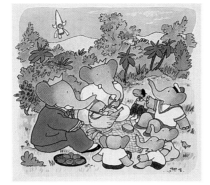

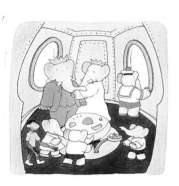

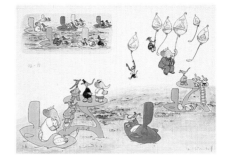

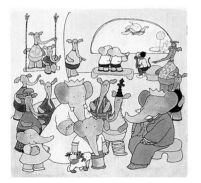
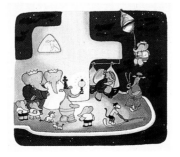

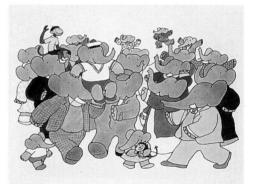

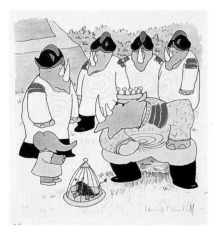

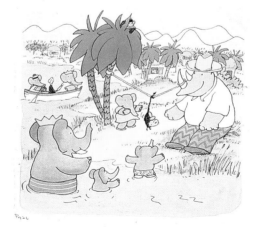

BABAR'S ADVENTURES, Calendar for 1989

Seascapes

Martha's Vineyard Series

Notes

Beginnings:
The Work of Jean de Brunhoff

1. Émile de Sabouraud's observations and quotations all come from a conversation between him and the author recorded in Paris on February 23, 1988.

2. This is according to Cécile de Brunhoff, in a tape-recorded conversation we had in Paris on February 21, 1988. I am indebted to Mme de Brunhoff for the information she provided then as well as on July 2, 1988, and in several subsequent telephone calls and letters.

3. Conversation with Mathieu de Brunhoff in Paris on February 21, 1988.

4. Unless otherwise indicated, all quotations from Laurent de Brunhoff came from conversations between him and the author held in Middletown, Connecticut, in 1987 and 1988.

5. "Homage to Babar on His 50th Birthday," introduction by Maurice Sendak to *Babar's Anniversary Album*, New York: Random House, 1981, p. 7.

6. Janet Flanner, *Paris Was Yesterday*, New York: Viking Press, 1972, p. 67.

7. Flanner, *Paris Was Yesterday*, p. 67.

8. Flanner, *Paris Was Yesterday*, p. 73.

9. All quotations from the Babar books come from their Random House editions.

10. E. H. Gombrich, *Art and Illusion*, Princeton, N.J.: Princeton University Press, 1960, p. 334.

11. Gombrich, *Art and Illusion*, pp. 334–35. On February 21, 1987, I visited Lord Gombrich in London. We sat in his scholarly library discussing another project in which he was politely but not unusually interested. However, when I mentioned that my next undertaking would be *The Art of Babar*, he practically jumped to his feet with excitement; while I thought that he might tell me that I would be better off pursuing a theme like formalism in late nineteenth-century Bavarian art—a subject he had just brought up in relation to the topic under discussion—he said of the de Brunhoff idea, "Congratulations! I cheer you on! . . . I am very excited. . . . This is commendable, very much worthwhile." He expressed admiration for the sheer wit of the books, "the economy of line and economy of means." de Brunhoff "is wonderful because his line is always very careful, very short. He is not verbose in his telling of the story. All the details are in the background, very rich."

12. I am indebted to Peter Chelkowski of New York University for providing me with information on this subject.

13. Bettelheim, however, does not have views specifically about the Babar books. In reply to a letter I sent him on the subject, he wrote, in a letter of January 19, 1988, "I regret that I am not sufficiently versed in the Barbar [sic] books to be able to be of help to you."

14. Bruno Bettelheim, *The Uses of Enchantment*, New York: Random House, Vintage Books, 1977, p. 8.

15. Bettelheim, *The Uses of Enchantment*, p. 8.

16. Bettelheim, *The Uses of Enchantment*, p. 5.

17. Bettelheim, *The Uses of Enchantment*, p. 11.

18. I am grateful to the psychiatrist Kyle Pruett for this idea, which he expressed in a talk to parents of kindergartners at the Foote School in New Haven, Connecticut, on April 19, 1988.

19. Among those who were originally shocked by Babar's handling of his mother's death was Maurice Sendak. On page 8 of his introduction to *Babar's Anniversary Album*, Sendak confesses that "the ease and remarkable calm

with which de Brunhoff blighted the life of his baby elephant numbed me. That sublimely happy babyhood lost, after only two full pages, and then, as in a nightmare (and too much like life), Babar, cruelly and arbitrarily deprived of his loving mother, runs wildly out of babyhood (the innocent jungle) and into cozy, amnesia-inducing society (Paris, only blocks from that jungle). It is there that he feverishly embraces adulthood, culture, manners, any surface, to hide the hideous trauma of that useless death. Or so it seemed to me then."

20. I am indebted to Darlene Geis for pointing this out to me.

21. There are examples in more recent French literature as well. For example, in Emmanuel Bove's *Armand* of the 1920s, the novel's narrator "is rescued from freezing garrets and cheap wine shops by Jeanne, a wealthy older woman (Armand is 30) who installs him in her plush apartment and keeps him in clothes." (The quotation is from a book review by Oliver Conant of a recent translation of *Armand* in the *New York Times Book Review,* January 24, 1988, p. 11.)

22. Charlotte Fox Weber, in conversation in Glandore, County Cork, Ireland, August 19, 1988.

23. Bettelheim, *The Uses of Enchantment,* p. 47.

24. Lucy Swift Weber, in conversation in Bethany, Connecticut, on July 18, 1988.

25. John Russell, *Paris,* New York: Harry N. Abrams, 1983, p. 27.

26. Russell, *Paris,* p. 333.

27. Phyllis Rose amplifies this theme in an unpublished 1971 essay, *Children's Books, Adult Readers: The Case of the Elephants.*

28. Ariel Dorfman, on page 22 of *The Empire's Old Clothes,* sees the first three Babar books as presenting "a theory of history, an unconscious method for interpreting the contemporary economic and political world" that always pits city against jungle, civilized against primitive, in favor of the former. (Ariel Dorfman, *The Empire's Old Clothes: What the Lone Ranger, Babar, and Other Innocent Heroes do to Our Minds,* New York: Pantheon Books, 1983. I am grateful to Henry Schwab for calling this book to my attention.) Dorfman claims on page 23 that Jean de Brunhoff, with "the self-assurance that goes with being a member of a colonizing nation with several centuries of experience in the field," equates native habits with trouble, and emphasizes the need for submission. On page 28 he writes, "The message is: assimilate. The stages in the conquest and enslavement of Africa, therefore, have been incorporated in a way that changes their meaning and inverts their truth. Of course, children, we cannot tell a lie. There was some plundering, but just look how happy the elephants are now." Few children's books—be they the Eloise or Madeleine books or Beatrix Potter's tales—could survive this sort of interpretation. And even if the Babar books can be seen as representing certain values, the attribution of such specific motives to the de Brunhoffs is erroneous. Their books simply contain the requisites of much fiction for children and of French painting from the past three centuries: violence, capture, escape; the ways of royalty, delicious sugary food, fancy clothing.

29. Christina Hardyment, in *Heidi's Alp* (New York: Atlantic Monthly Press, 1987), says erroneously that Jean de Brunhoff was in a sanatorium when he wrote *The Story of Babar* and hence was both absent from his children and anticipating his own death from the moment he began writing his books. In fact, Cécile de Brunhoff says that although Jean was not terribly robust, he had no intimations of his impending death when he created the early books.

30. The architecture of Celesteville is discussed in great detail by Lloyd Grossman in an article, "Babar the Architect," that appeared in *Harpers & Queen* in May, 1984. Mr. Grossman finds links to Garnier, Alberti, and others.

31. John Maxtone-Graham, *The Only Way to Cross,* New York: Macmillan Co., 1972, p. 279. I am indebted to Gail Brand for bringing this book to my attention, and to Lucy Swift Weber for having the presence of mind at age six to tell Ms. Brand, her camp counselor, that I was writing about Babar.

32. This opinion is not universal. Maurice Sendak, on page 15 of his introduction to *Babar's Anniversary Album,* calls *Babar and His Children* "the most moving of the series."

Continuation:
The Work of Laurent de Brunhoff

1. A. J. Liebling, *The Road Back to Paris,* New York: Paragon House, 1988, p. 40.

2. Statement in undated publicity brochure entitled "Laurent de Brunhoff," New York: Random House, Library Marketing.

3. My wife Katharine Weber, in an interview with Laurent de Brunhoff in *Connecticut Magazine* in May, 1987, queried him about the spike. "Is any sexual imagery intentional? 'Probably,' agrees de Brunhoff cheerfully."

4. Desiderius Erasmus, *The Praise of Folly,* translated by Clarence H. Miller, New Haven and London: Yale University Press, 1979, p. 23.

5. Random House publicity brochure.

6. The relationship of Boover and Picardee to Flaubert's characters was first brought to my attention in the unedited version of my wife's *Connecticut Magazine* interview. It is further explored by Carl Little in his unpublished essay "The Art of Babar."

The Illustrations

Unless otherwise indicated, these illustrations all reproduce original watercolors by Jean and Laurent de Brunhoff. Looking at the material in this form, we get to see the true quality of these artists' work to an extent not possible in the Babar books themselves. The fineness of detail and the richness of the brushwork should be apparent in a new way. Additionally, the original colors of this art are sometimes very different from the colors that appear in the books, particularly in the case of Jean de Brunhoff's paintings. This is both because de Brunhoff's watercolors have faded to a degree, and because the early printers intensified the hues considerably. In any event, the books that were the purpose of this art are ideal companions to this volume. Not only do they offer interesting comparisons, but they tell the Babar stories in their entirety and show all the illustrations, while what is reproduced here is more of a retrospective overview.

The whereabouts of some of Jean de Brunhoff's paintings remain unknown. Thirty-six original watercolors and drawings were sold at an exhibition held in New York at Durlacher Brothers in May, 1938—the year after his death. The show had been organized by Jean's brother in order to help raise some money for the artist's widow. One picture sold in that exhibition has surfaced and has been reproduced in this book, for which I heartily thank the owner; it can only be hoped that the location of more of the original art will eventually be known.

About the captions: unless a collection is cited, the art by Jean de Brunhoff shown in this book comes from the artist's estate, and is reproduced courtesy of his heirs. Laurent de Brunhoff's work (except where otherwise indicated) comes from the artist's own collection, and in many instances is reproduced courtesy of the Mary Ryan Gallery, New York. Although all of the books until 1963 were first published in French, I have used their English titles. The dates given are the publication dates of the books. In the case of the books that appeared during Jean de Brunhoff's lifetime (all but *Babar and His Children* and *Babar and Father Christmas*), and for all of Laurent de Brunhoff's books, it can be assumed that the original art reproduced here was made in the year or two preceding the publication date. In the case of Jean de Brunhoff's two posthumous books, the art was drawn earlier although colored by other people shortly before the publication date, as explained in the text.

When sizes of art are given, height precedes width. N.F.W.

Acknowledgments

This book would not have been possible without the extraordinary cooperation of Laurent de Brunhoff. He is a painter of tremendous skill who suffers from none of the ego complications that so often afflict even nonpainting members of artists' families. His eye for both his father's and his own work, his insights into myriad subjects, and his kind and easy approach to everyday dealings have contributed immeasurably to the pleasure of my work. And knowing that I would find Phyllis Rose nearby whenever I visited Laurent has been an incalculable bonus. Her sparkling presence and brilliance about the written word are without equal. I thank her particularly for the title of this book, for her suggestions on its scope, for her generous and perceptive commentary on the text, for her continuous support and humor, and above all for her friendship.

Cécile de Brunhoff, Émile de Sabouraud, and Mathieu de Brunhoff have also been extremely helpful. To encounter people so giving and gracious has been a tremendous boon.

This book would not have taken form without the consent of Robert Bernstein of Random House, whom I thank warmly. In a very different way, the undertaking would not have been feasible without the kind support of Anni Albers, Lee Eastman, and the other directors of the Josef Albers Foundation, in allowing me the flexibility as executive director of that foundation to devote so much time to Babar during the past two years. I thank Ann Ameling for her invaluable support in providing the haven that is a writer's dream. My great appreciation goes to Marie-Claude de Brunhoff for her helpfulness in supplying both photographs and useful background information. I thank Gloria Loomis for turning this undertaking into a reality—and making the process such an ongoing delight. I am grateful to Paul Gottlieb, a Babar aficionado since the age of three, for his enthusiasm from the start.

My special thanks also go to Darlene Geis. There could have been no better match of topic and editor. Like the Babar stories, she is warm, worldly, savvy, and full of humor, spirit, and insights.

Appreciation goes as well to Sam Antupit and Maria Miller for the attention they have shown to the design of this book and the quality of the reproductions. Additionally, I acknowledge—for their various, indispensable forms of assistance—Irene Perez, Kelly Feeney, Angela Tau Bailey, Emma Lewis, Phyllis Fitzgerald, Panj Doshi, Ruth Davidson, Nicholas Ohly, Kaye Betts, Irene Seligman, B. Philip Svigals, Carol Fuerstein, Beth Vesel, Nikki Rolfe, Mary Ryan, Laurence Hovde, James Wechsler, Kendra Taylor, and those individuals whose specific forms of assistance are cited in the footnotes.

My wife Katharine interviewed Laurent for *Connecticut Magazine* before I embarked on this project, and her knowledge of him and his work have helped me tremendously along the way. I could not have realized this book without her role as both a perspicacious critic and above all a splendid spouse.

The Babar books celebrate everyday living in an unequaled way. They extol the beauties of visual experience and daily events, in part by approaching them from a childlike vantage point. My own children have done more than anyone else to make me feel at home in the earthly paradise set forth in the volumes of Jean and Laurent de Brunhoff. To two great little girls—Lucy Swift Weber and Charlotte Fox Weber—I dedicate this book.

N.F.W.
October, 1988

Books by Jean and Laurent de Brunhoff

Jean de Brunhoff

THE STORY OF BABAR. *Histoire de Babar,*
 Editions du Jardin des Modes, 1931.
THE TRAVELS OF BABAR. *Le Voyage de Babar,*
 Editions du Jardin des Modes, 1932.
BABAR THE KING. *Le Roi Babar,*
 Editions du Jardin des Modes, 1933.
THE ABC OF BABAR. *ABC de Babar,*
 Editions du Jardin des Modes, 1934.
BABAR AND ZEPHIR. *Les Vacances de Zephir,*
 Hachette, 1936.
BABAR AND HIS CHILDREN. *Babar en Famille,*
 Hachette, 1938.
BABAR AND FATHER CHRISTMAS. *Babar et le Père Noël,*
 Hachette, 1941.
BABAR'S ANNIVERSARY ALBUM.
 Jean and Laurent de Brunhoff, Random House, 1981.

Laurent de Brunhoff

BABAR'S COUSIN: THAT RASCAL ARTHUR.
 Babar et ce coquin d'Arthur, Hachette, 1946.
BABAR'S PICNIC. *Pique-nique chez Babar,*
 Hachette, 1949.
BABAR'S VISIT TO BIRD ISLAND.
 Babar dans l'île aux oiseaux, Hachette, 1951.
BABAR'S FAIR. *La fête de Celesteville,* Hachette, 1954.
BABAR AND THE PROFESSOR.
 Babar et le professeur Grifaton, Hachette, 1956.
BABAR'S CASTLE. *Le Château de Babar,* Hachette, 1961.
BABAR'S FRENCH LESSONS. Random House, 1963.
BABAR COMES TO AMERICA. Random House, 1965.
BABAR LOSES HIS CROWN. Random House, 1967.
BABAR'S GAMES (Pop-up). Random House, 1968.
BABAR GOES TO THE MOON (Pop-up).
 Random House, 1969.
BABAR'S TRUNK (little books Hachette, 1966).
 Random House, 1969.
BABAR'S BIRTHDAY SURPRISE. Random House, 1970.

BABAR'S OTHER TRUNK (little books Hachette, 1969).
 Random House, 1971.
BABAR VISITS ANOTHER PLANET. Random House, 1972.
MEET BABAR AND HIS CHILDREN. Random House, 1973.
BABAR'S BOOKMOBILE (little books Hachette, 1970).
 Random House, 1974.
BABAR AND THE WULLY-WULLY. Random House, 1975.
BABAR SAVES THE DAY. Random House, 1976.
BABAR LEARNS TO COOK. Random House, 1978.
BABAR'S MYSTERY. Random House, 1978.
BABAR THE MAGICIAN (shape book). Random House, 1980.
BABAR'S LITTLE LIBRARY (Air, Earth, Fire, Water).
 Babar Box. *Die vier Elemente.* Diogenes Verlag, 1980.
BABAR AND THE GHOST. Random House, 1981.
BABAR'S ABC. Random House, 1983.
BABAR'S ANNIVERSARY ALBUM.
 Jean and Laurent de Brunhoff, Random House, 1981.
BABAR'S BOOK OF COLOR. Random House, 1984.
BABAR'S COUNTING BOOK. Random House, 1986.
BABAR'S LITTLE GIRL. Random House, 1987.
BABAR'S LITTLE CIRCUS STAR. Random House, 1988.

Other books by Laurent de Brunhoff

À TUE-TÊTE. Julliard, 1957.
SERAFINA THE GIRAFFE. World Publishing, 1961.
SERAFINA'S LUCKY FIND. World Publishing, 1962.
CAPTAIN SERAFINA. World Publishing, 1963.
ANATOLE AND HIS DONKEY. MacMillan, 1963.
BONHOMME. Pantheon, 1965.
GREGORY AND LADY TURTLE. Pantheon, 1971.
BONHOMME AND THE HUGE BEAST. Pantheon, 1974.
ONE PIG WITH HORNS. Pantheon, 1979.

Calendars

BABAR'S ADVENTURES, Calendar for 1988.
 Jean and Laurent de Brunhoff. Stewart, Tabori & Chang, 1987.
BABAR'S ADVENTURES, Calendar for 1989.
 Laurent de Brunhoff. Stewart, Tabori & Chang, 1988.

Index

Page numbers in *italics* refer to illustrations

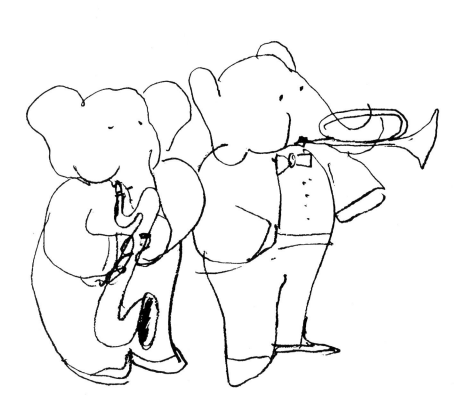

Print and binding
Officine Grafiche Garzanti
Milano - Italy